The Movable Book Society Meggendorfer Awards

Celebrating Paper Engineers, Book Artists & Pop-Up Books 1998 – 2018

First Edition

Edited by Kyra E. Hicks

The Movable Book Society
Chicago, Illinois

Extensive effort has gone into ensuring the information within these pages is correct; however, the publisher makes no warranty, express or implied, with respect to the materials herein.

Includes bibliographical references and index.
ISBN: 978-0-9746775-1-4

Library of Congress Subject Headings:
1. Movable Book Society
2. Movable Book Society--Awards
3. Toy and movable books--History
4. Literary prizes
5. Meggendorfer, Lothar

Book Layout: Karen Krug | Krug Enterprises, Inc. | www.kei.guru

Thanks are given to the paper engineers, book artists and BestPopUpBooks.com for providing photographs and information for this project.

TABLE OF CONTENTS

Foreword ... ii

About Lothar Meggendorfer... 1

The Meggendorfer Prize: A Historical Perspective 3

The Meggendorfer Prize for Best Paper Engineering 1998 – 2018 5

The Movable Book Society Outstanding Emerging Paper Engineer
Prize 2014 – 2018 .. 51

The Meggendorfer Prize for Best Artist Book 2014 – 2018................................ 60

The Movable Book Society Lifetime Achievement Award................................ 67

Movable Book Society Board of Advisors ... 70

Paper Engineer, Book Artist and Collector Index................................. 71

Foreword

by Shawn Sheehy, Director
The Movable Book Society

Mine is a very predictable piece in an overall fairly unusual pattern.

I have been a practicing paper engineer for over 20 years. With the exception of a handful of grad school weekend workshops (grateful nods to Carol Barton and Hedi Kyle), I have had no formal training in paper engineering. And yet, with that lack of formal training, I have produced six pop-up artist books, two pop-up trade books, participated in a number of commercial commissions, and taught paper engineering workshops regularly.

The predictable part: My story isn't unique. The unusual part: A high percentage of contemporary paper engineers are self-taught. Academia (with a few notable exceptions) simply hasn't found a place for making pop-ups. When paper engineers want to learn (more), they pull apart an existing pop-up, grab a familiar how-to book (further grateful nods to David A. Carter, James Roger Diaz and Duncan Birmingham), or sit down for YouTube instruction.

Fortunately for me—and I think the same is true for many others—there is yet another vital resource for paper engineers: The Movable Book Society. I attended my first meeting in 2002, and I found my people. I brought along a little project I was working on, and I received terrific feedback and encouragement. (The project ultimately became [full disclosure] 2016 Meggendorfer Award winner *Welcome to the Neighborwood*.) It was at the San Diego meeting in 2004 that I clearly saw the viability of making a living as a paper engineer.

You will read in the following pages a historical piece from Ellen G. K. Rubin, who—together with Movable Book Society founder Ann Montanaro Staples—established the Meggendorfer Prize. A brief history of Lothar Meggendorfer will highlight why he is worthy of having a prestigious award named in his honor. And, you will discover an exhaustive listing of award winners, honorable mentions and more. You will also read of the recipients of The Meggendorfer Prize for Best Artist Book and The Outstanding Emerging Paper Engineer Prize. The Society hopes that you will find this to be a valuable research tool and a useful guide to discovering and enjoying the best our field has to offer.

At its inception, The Movable Book Society established the goal of recognizing and celebrating the art, technique, and mastery of paper engineering. In publishing this book, the MBS demonstrates its ongoing commitment to that goal, as well as its hope in inspiring and easing the path of the next generation of paper engineers. When "teaching yourself" is the only means to an end, a little support and encouragement from your community can make a big difference.

About Lothar Meggendorfer

By Kyra E. Hicks

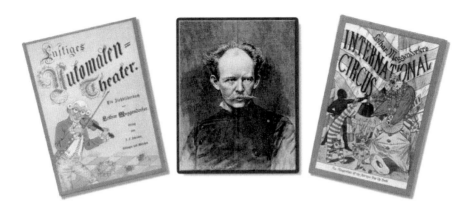

Lothar Meggendorfer (1847-1925), the nineteenth century paper engineering genius, was born in Munich to Johann and Karoline (Sicherer) Meggendorfer, the youngest of his father's twenty-five children from two marriages. In 1873, Meggendorfer married Elise Roedel. The couple eventually had two sons and four daughters.

After his technical art studies, Meggendorfer worked several years as an illustrator for the German satirical magazine *Fliegende Blätter*. He also contributed to *Münchener Bilderbogen*, a single-page publication or picture sheet.

From an early age, Meggendorfer was influenced by Münich-based puppeteer, Josef Schmid, and later himself became a puppeteer and infused his art with humor and illustrations with puppet-like movements.

In 1878, Meggendorfer created his first privately-produced movable toy book, *Lebende Bilder* (*Living Pictures*) as a Christmas gift to his eldest son, Adolf. During his book career, Meggendorfer published stories using various mechanical techniques:

- Two four-panel slat Illustration layered so a pulled tab transforms one image to the next.
- Multiple illustrations bound and cut into three parts to mix and make new illustrations, like today's metamorphosis or exquisite corpse artist books
- Three-dimensional panoramas
- Pull-tabs and movable figures

Movable books with pull-tabs were not new. The "genius" of Meggendorfer manifested itself through his innovations with pull-tabs. Ann Montanaro Staples, the Movable Book Society founder, writes:

"In contrast to most of his contemporaries, Meggendorfer was not satisfied with only one action on each page. He often had five parts of the illustration move simultaneously and in different directions.

"Meggendorfer devised intricate levers, hidden between pages, that gave his characters enormous possibilities for movement. He used tiny metal rivets to attach the levers, so that a single pull-tab could activate all of them, often with several delayed actions as the tab was pulled farther out. Some illustrations used more than a dozen rivets."

Meggendorfer is believed to have created more than 200 movable books between 1878 and 1910, with sales over a million copies. The books were translated and distributed in Czechoslovakia, Belgium, England, France, Russia, America and more.

Original illustrations and books by Meggendorfer are collectible and occasionally offered by antiquarian booksellers and auction houses. For those interested in studying Meggendorfer's work, the University of California, Los Angeles Library and the University of Wisconsin, Madison Library special collections include manuscripts, books and illustration proofs.

Though he died nearly a century ago, Lothar Meggendorfer's name continues to inspire. In the late 1970s, several of his movable books, such as *The Doll's House*, *International Circus*, and *Surprise! Surprise!*, were reproduced for a new generation. In the 2010s, a specialty pop-up bookstore named "Meggendorfer" in Kamakura, south of Toyko, welcomed customers.

Every two years since 1998, the Movable Book Society has awarded the Meggendorfer Prize for Best Paper Engineering to honor contemporary paper engineers whose published work exemplifies the imagination, magic, storytelling and craftsmanship exhibited by Lothar Meggendorfer.

Sources:
- Bahar, Ann. "Lothar Meggendorfer and the Movable Toy Book." *Hobbies*, December 1983.
- Barghouti, Kim, comp. *Who's Who in the World, 1910-1911*, Ancestry.com, 2001.
- Haining, Peter. *Movable Books: An Illustrated History*. London: New English Library, 1979.
- Krahé, Hildegard. "Biographisches." Lothar Meggendorfers Lebende Bilderbücher, Puppentheatermuseum im Münchner Stadtmuseum, 1981.
- "Lothar Meggendorfer." Contemporary Authors Online, Gale, 2006.
- Schiller, Justin G, and Maurice Sendak. *The Publishing Archive of Lothar Meggendorfer*. New York: Justin G. Schiller, 1975.
- Phillips, Trish, and Ann Montanaro. *Creative Pop-Up, a History and Project Book*. London: Southwater Pub, 2014.
- *Pop-ups!: A Guide to Novelty Books*. London: Booktrust, 2002.

The Meggendorfer Prize: A Historical Perspective

by Ellen G. K. Rubin

It was probably in 1994 or 1995, when the Newbery or Caldecott Medals were being awarded, that it occurred to me that if writers (Newbery) and illustrators (Caldecott) of children's books were being recognized and celebrated, then paper engineers should be celebrated too. What is a pop-up book without a paper engineer? Answer: A flat book. In collecting pop-up and movable books since the 1980s, I couldn't help but notice that up until the mid-20th century, before interactive book publisher and packager Intervisual Books dominated the field in the 1980s and 90s, paper engineers were not given credit for their work. I was outraged.

At this time, The Movable Book Society was just getting on its feet, having been founded by Ann Montanaro [Staples] in 1993. By 1996, it had already staged its first conference at Rutgers University, where Ann was the head of Information Technology for the university's libraries. The conference included a pop-up book exhibition based on Ann's collection, a series of lectures on topics relevant to our focus, and two hands-on workshops. It occurred to me that we should present a prize at our next conference that celebrates the work of paper engineers whose artistry we were coming together to learn about.

I approached Ann with the idea of a prize for the best pop-up or movable book to be awarded at each conference. Since we considered Lothar Meggendorfer to be "The Genius" of paper engineering, the prize should bear his name. Ann was immediately on board and she developed the criteria and the process by which the prize would be chosen. We compiled the names of published pop-up and movable books that would be considered at the next MBS conference in Los Angeles, CA.

The criteria for evaluation was (and still is) based on originality, artistry, the overall text and functionality, and how well the mechanics work. Judges were asked to consider the innovative use of movables and how the integration of pop-ups and/or movables supports the book's story and its overall appeal. We hoped that the Meggendorfer Prize would become recognized and sought after throughout the pop-up book world.

Ann and I—there was no Movable Book Society Board as yet—vetted what we thought were the most outstanding books. Ann produced a ballot. Only those attending the Los Angeles conference would be voting. The prize would be presented at the conference's banquet as our final event. An etched glass award was presented to the winner, Robert Sabuda, for his *The Christmas Alphabet* (Orchard Books, 1994). Robert went on to win the next two times, in 1998 and 2000, and thereafter recused himself from the competition. Adie Peña, later an MBS board member, created the original MBS logo, that can be seen on the first award.

At the 2000 conference in New York City, I was given the honor of presenting the Meggendorfer Prize for Best Paper Engineering. It has been my pleasure to award it ever since.

Beginning at that 2000 conference, the voting process was expanded to include the entire MBS membership worldwide. A list of published pop-up and movable book candidates for the two years preceding the conference was mailed with the MBS *Movable Stationery* newsletter. Members were encouraged to mail in their ballots. Beginning with the 2018 conference, MBS Board Member Jason Brehm managed the vetting process and introduced online balloting with an image of each book to accompany the mailed-in ballots.

At the Milwaukee conference in 2002, the vetted books were on display for the first time. This allowed conference attendees to examine books they possibly had never seen, especially movable and pop-up books of small runs or of foreign publication.

In 2014, the MBS Board created the Meggendorfer Prize for Best Artist Book. With this prize, the MBS celebrates limited-edition artist books as well as trade publications.

The Movable Book Society continues to expand, innovate, and gather members from wider and wider spheres. New people with new ideas have helped to support the MBS's mission: to make an impact on the pop-up book industry, to educate the public about the books we love, and to celebrate paper engineers, those artists responsible for the dynamic presentation of books for adults as well as children.

Ellen G. K. Rubin (aka The Popuplady) is a founding member of The Movable Book Society and a noted pop-up book historian. Her personal collection includes more than 10,000 books and ephemera.

The Meggendorfer Prize
for Best Paper Engineering
1998 – 2018

Simon Arizpe, Paper Engineer

Simon Arizpe is an award-winning paper engineer and illustrator based in Brooklyn, NY. A graduate of the Pratt Institute, Arizpe worked in pop-up book design for over ten years. His work is included in the permanent collection of The Smithsonian's Cooper-Hewitt Design Museum Library and received the Society of Illustrator's Award of Excellence. Arizpe teaches paper engineering and three-dimensional design at The Pratt Institute and Parsons School of Design.

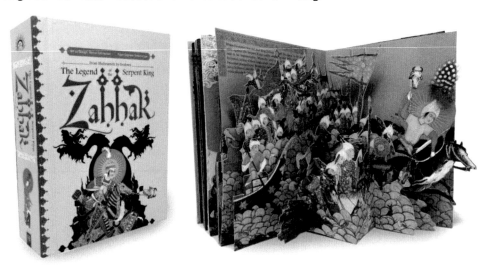

Zahhak: The Legend of the Serpent King by Ahmad Sadri and Melissa Hibbard, art and design by Hamid Rahmanian. Simon Arizpe, paper engineer. Fantagraphics Books, 2017. This well-crafted pop-up book features richly detailed royal scenes, mystical caves, springing serpents, and mighty battles in three dimensions.

2018 MEGGENDORFER PRIZE FINALISTS

Announced at the MBS Conference in Kansas City, Missouri
September 27-29, 2018

Keith Allen, Paper Engineer.
What a Mess! A Pop-Up Misadventure by Keith Allen. 5am Press LLC, 2017.

Kelli Anderson, Paper Engineer.
This Book Is a Planetarium: And Other Extraordinary Pop-Up Contraptions: a Speaker, a Spiralgraph, a Decoder Ring, *a Perpetual Calendar, a Musical Instrument* by Kelli Anderson. Chronicle Books, 2017.

Simon Arizpe, Paper Engineer.
Zahhak: The Legend of the Serpent King by Ahmad Sadri and Melissa Hibbard, art and design by Hamid Rahmanian. Simon Arizpe, paper engineer. Fantagraphics Books, 2017.

Maike Biederstädt, Paper Engineer.
Creatures of the Deep: The Pop-Up Book, concept and paper engineering by Maike Biederstädt. Illustrated by Ernst Haeckel. Prestel, 2018.

Yoojin Kim, Paper Engineer.
Leaves: An Autumn Pop-Up Book by Janet Lawler, illustrated by Lindsay Dale-Scott. Yoojin Kim, paper engineer. Up with Paper, 2017.

Rosston Meyer, Paper Engineer.
Junko Mizuno's Triad Pop-Up Book, illustrated by Junko Mizuno. Book design and paper engineering by Rosston Meyer; paper engineering of tree by Simon Arizpe. Poposition Press, 2016.

Courtney Watson McCarthy, Paper Engineer.
ABC Pop-Up by Courtney Watson McCarthy. Candlewick Studio, 2017.

David Pelham, Paper Engineer.
Raven: A Pop-Up Book by Edgar Allan Poe, illustrated by Christopher Wormell. David Pelham, paper engineer. Abrams Books, 2016.

Shawn Sheehy, Paper Engineer

Chicago-based pop-up book artist Shawn Sheehy mixes paper engineering with a detailed interest in biology, evolution, and sustainability. Sheehy has published two trade pop-up books: *Welcome to the Neighborwood* (2015) and *Beyond the Sixth Extinction* (2018). His broadsides and artist books have been collected by many prestigious institutions. He has been teaching book arts courses and workshops since 2001. Sheehy holds an MFA in Book Arts from Columbia College Chicago. Since 2018, he has served as director of The Movable Book Society.

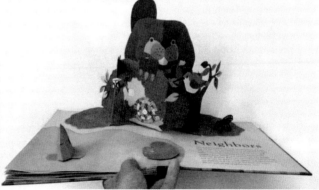

Welcome to the Neighborwood: A Pop-Up Book of Animal Architecture by Shawn Sheehy. Candlewick Press, 2015. Visit the homes and habitats—and explore the relationships—of seven woodland creatures.

2016 MEGGENDORFER PRIZE FINALISTS

Announced at the MBS Conference in Boston, Massachusetts
September 15-17, 2016

Anouck Boisrobert, Louis Rigaud, Paper Engineers.
That's My Hat by Anouck Boisrobert and Louis Rigaud. Thames & Hudson, 2016.

Bruce Foster, Paper Engineer.
The White House Pop-Up Book by Chuck Fischer. Bruce Foster, paper engineer. Commonwealth Editions, 2014.

Gérard Lo Monaco, Paper Engineer.
The Small World of Paper Toys by Gérard Lo Monaco. Translated from French by Noelia Hobeika. Die Little Gestalten, 2015.

Ray Marshall, Paper Engineer.
Paper Blossoms: Butterflies & Birds: A Book of Beautiful Bouquets by Ray Marshall. Chronicle Books, 2014.

Courtney Watson McCarthy, Paper Engineer.
Dali Pop-Ups by Courtney Watson McCarthy. Artwork by Salvador Dalí. Thames & Hudson, 2014.

Denise D. Price, Paper Engineer.
Freedom Trail: Pop Up Book of Boston by Denise D. Price. White Dharma Limited, 2015.

Matthew Reinhart, Paper Engineer.
Disney Princess: Magical Pop-Up World by Matthew Reinhart. Insight Editions, 2015.

Game of Thrones: A Pop-Up Guide to Westeros, illustrated by Michael Komarck. Matthew Reinhart, paper engineer. Bantam Press/Home Box Office, 2014.

Robert Sabuda, Paper Engineer.
The Dragon & the Knight: A Pop-Up Misadventure by Robert Sabuda. Simon & Schuster, 2014.

Shawn Sheehy, Paper Engineer.
Welcome to the Neighborwood: A Pop-Up Book of Animal Architecture by Shawn Sheehy. Candlewick Press, 2015.

Sarah Tavernier, Paper Engineer.
Legendary Routes of the World: A Pop-Up Book by Alexandre Verhille and Sarah Tavernier. Translated by David Henry Wilson. Sarah Tavernier, paper engineer. Little Gestalten, 2015.

Yevgeniya Yeretskaya, Paper Engineer.
The Mitten: A Classic Pop-Up Folktale by Jessica Southwick, illustrated by Pippa Curnick. Yevgeniya Yeretskaya, paper engineer. Jumping Jack Press, 2016.

Becca Zerkin, David Hawcock, Paper Engineers.
The Walking Dead Pop-Up Book by S. D. Perry, illustrated by Sally Elizabeth Jackson. Becca Zerkin and David Hawcock, paper engineers. Insight Editions, 2015.

On being a paper engineer...

"I am a self-taught paper-engineer. I bought broken pop-up books online to conduct engineering research. I used Kickstarter in 2014 (to fund Freedom Trail: Pop Up Book of Boston) when crowdfunding had nearly reached a peak in popularity. If I could do it again, I would have started with a lower funding goal (not the entire amount needed) that could be funded faster. I believe people "jump in" once the project is funded so they know they will actually receive the rewards.

"Finding my pop-up peers within the Movable Book Society has been an enriching experience for me. I am able to network with other engineers, stay connected to the creativity of the artists, and have an inside view of what will be coming to the market in the 'pop-up' world."

Denise D. Price, Paper Engineer

Matthew Reinhart,
Paper Engineer

Matthew Reinhart was born in Cedar Rapids, Iowa, but frequently moved as a child, fostering his creativity. His nearly 40 pop-up titles include the #1 *New York Times* bestseller *Star Wars: Pop-Up Guide to the Galaxy*, *Encyclopedia Prehistorica* trilogy, *Game of Thrones: A Pop-Up Guide to Westeros*, *Harry Potter: A Pop-Up Guide to Hogwarts* and *Disney Princess: A Pop-Up World.*

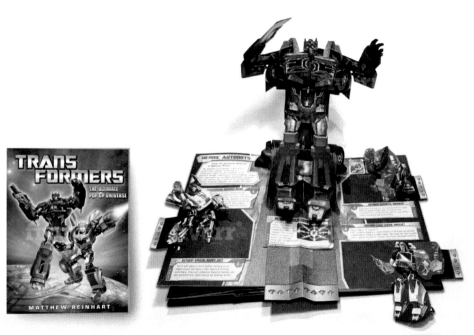

Transformers: The Ultimate Pop-Up Universe, illustrated by Emiliano Santalucia. Matthew Reinhart, paper engineer. Little Brown Kids, 2013. Autobots, Decepticons, and other alien robots morph into vehicles and back at the turn of a page. See if you can contain one of Reinhart's tallest pop-up structure, Omega Supreme, the mightiest Autobot, between the book covers.

2014 MEGGENDORFER PRIZE FINALISTS

Announced at the MBS Conference in Philadelphia, Pennsylvania
September 18-20, 2014

Marion Bataille, Paper Engineer.
Numero by Marion Bataille. Chronicle Books, 2013.

Anouck Boisrobert, Louis Rigaud, Paper Engineers.
*Oceano (*also in English as *Under the Ocean)* by Anouck Boisrobert and Louis Rigaud. Corraini Edizioni, 2013.

Alan Brown, Julia Froehlich, Paper Engineers.
The Nutcracker by Geraldine McCaughrean, illustrated by Kristina Swarner. Alan Brown and Julia Froehlich, paper engineers. Chronicle Books, 2012.

David A. Carter, Paper Engineer.
The Lorax Pop-Up by Dr. Seuss. David A. Carter, paper engineer. Robin Corey Books, 2012.

Bruce Foster, Paper Engineer.
America's National Parks: A Pop-Up Book by Don Compton, illustrated by Dave Ember. Bruce Foster, paper engineer. W.W. West, Inc., 2013.

Courtney Watson McCarthy, Paper Engineer.
Gaudi Pop-Ups by Courtney Watson McCarthy. Featuring artwork by architect and designer Antoni Gaudi. Thames & Hudson, 2012.

Matthew Reinhart, Paper Engineer.
Star Wars: A Galactic Pop-Up Adventure, text by Lucasfilm Ltd. Designs by Chelsea Donaldson and Jessica Tice-Gilbert. Matthew Reinhart, paper engineer. Orchard Books, 2012.

Matthew Reinhart, Paper Engineer.
Transformers: The Ultimate Pop-Up Universe, illustrated by Emiliano Santalucia. Matthew Reinhart, paper engineer. Little, Brown and Company, 2013.

Robert Sabuda, Paper Engineer.
The Little Mermaid by Hans Christian Andersen. Robert Sabuda, paper engineer. Little Simon, 2013.

Philippe UG, Paper Engineer.
Funny Birds by Philippe UG. Prestel, 2013.

Gene Vosough, Paper Engineer.
Itsy Bitsy Spider by Richard Egielski. Gene Vosough, paper engineer. Atheneum Books for Young Readers, 2012.

Yevgeniya Yeretskaya, Paper Engineer.
Marvel Super Heroes vs. Villains: An Explosive Pop-Up of Rivalries by Yevgeniya Yeretskaya. Jumping Jack Press, 2012.

Yevgeniya Yeretskaya, Paper Engineer.
Snow Queen: A Pop-Up Adaptation of a Classic Fairytale by Hans Christian Andersen. Yevgeniya Yeretskaya, paper engineer. Jumping Jack Press, 2013.

On being a paper engineer...

"I learned paper engineering while helping novelty publisher Tango Books assemble "dummy" sales books for book fairs. I enjoyed the technical side of the dummy building – being good at Geometry and Maths at school. I studied illustration at Central St Martins College of Art, so I had a bit of skill using scalpels and art materials to create visuals.

"There was no one to learn paper engineering from, so I picked things up by taking books apart and assembling pop-ups using the cutter-guides by paper engineers, like David Hawcock or Ray Marshall. Gradually having proved that I had a bit of facility at making up neat and functioning dummy books, I was trusted to have a go at paper engineering some time titles from scratch.

"I've never counted how many books I've created, and tend not to look back at my old work, but I guess I've had a (paper engineering) hand in 6-8 books per year (pre 2005) and more recently perhaps 10-15 books per year. So in total it must be at least 150. I still get a thrill from seeing a scribbled sketch come to life as a successful pop-up."

Richard Ferguson, Paper Engineer

Ray Marshall, Paper Engineer

English-born Ray Marshall left his career as an art director with Avon Cosmetics and taught himself paper engineering. In 1979, his first book *The Crocodile and the Dumpertruck: A Reptilian Guide to London,* illustrated by Korky Paul, was published to much acclaim. In 1985, Marshall's *Watch It Work: The Car* won the Nestlé Smarties Prize for Children's Books (UK) for most innovative book of the year. Marshall, who lives in the San Francisco Bay area, has designed over twenty-five interactive books, including the "Paper Blossoms" series for Chronicle Books.

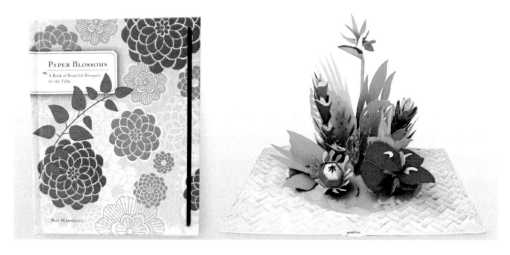

Paper Blossom: A Book of Beautiful Bouquets for the Table by Ray Marshall. Chronicle Books, 2010. Display amazing bird of paradise, irises, roses and more year-round.

Louis Rigaud and **Anouck Boisrobert,** Paper Engineers
1st Runner Up Honors

Anouck Boisrobert and Louis Rigaud form a creative author/illustrator duo, making pop-up books that stimulate the imaginations of the young and old alike. Both born in 1985, the pair met while attending courses at the École supérieure des arts décoratifs in Strasbourg, France. Together, they have written ten books. *Popville* was their first.

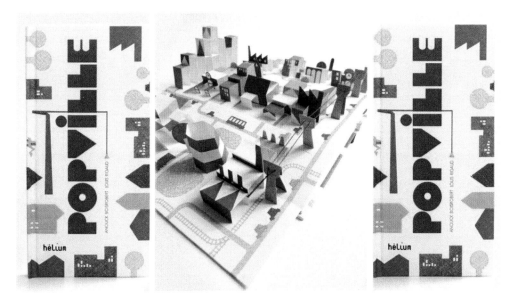

Popville by Anouck Boisrobert and Louis Rigaud. Roaring Brook Press, 2010. Turn the pages and watch a community grow from a single farmhouse to a bustling city.

Yevgeniya Yeretskaya is a Ukrainian-born, award winning artist who specializes in paper creations. In 2002, she graduated with a BFA in Communications Design from the Pratt Institute. Yeretskaya is Director of Paper Engineering at Up With Paper, a pop-up greeting card company. She has also published many books in the role of art director, illustrator or paper engineer through Jumping Jack Press.

Yeretskaya has dedicated her career to storytelling through movable books that enchant and engage the imagination.

Yevgeniya Yeretskaya,
Paper Engineer
2nd Runner Up Honors

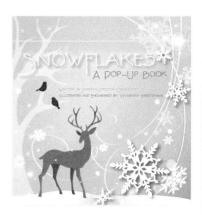

Snowflakes: A Pop-Up Book by Jennifer Chushcoff. Yevgeniya Yeretskaya, paper engineer. Jumping Jack Press, 2011. Wintery scenes, papery blizzards and swirling snowflakes make for enchanting reading. Photo by Devin Stoddard.

2012 MEGGENDORFER PRIZE FINALISTS

Announced at the MBS Conference in Salt Lake City, Utah
September 27-29, 2012

Anouck Boisrobert, Louis Rigaud, Paper Engineers.
Popville by Anouck Boisrobert and Louis Rigaud. Roaring Brook Press, 2010.

Bruce Foster, Paper Engineer.
A Christmas Carol: A Pop-up Book by Charles Dickens, adopted and illustrated by Chuck Fischer. Bruce Foster, paper engineer. Little Brown, 2010.

Harry Potter: A Pop-Up Book Based on the Film Phenomenon! Text by Lucy Kee and illustrated by Andrew Williamson. Bruce Foster, paper engineer. Insight Editions, 2010.

Sam Ita, Paper Engineer.
Frankenstein: A Pop-Up Book by Sam Ita. Retelling of the novel by Mary Shelley. Sterling Innovation, 2010.

Ray Marshall, Paper Engineer.
Paper Blossom: A Pop-Up Book of Beautiful Bouquets for the Table by Ray Marshall. Chronicle Books, 2010.

Courtney Watson McCarthy, Paper Engineer.
M.C. Escher Pop-Ups by Courtney Watson McCarthy. Features the graphic artwork of Maurits Cornelis Escher. Thames & Hudson, 2011.

Kees Moerbeek, Paper Engineer.
Aesop's Fables: A Pop-Up Book of Classic Tales illustrated by Chris Beatrice and Bruce Whatley. Kees Moerbeek, paper engineer. Little Simon, 2010.

Matthew Reinhart, Paper Engineer.
DC Super Heroes the Ultimate Pop-Up Book by Matthew Reinhart. Text and art by DC Comics. Matthew Reinhart, paper engineer. Little, Brown and Company, 2010.

Robert Sabuda, Paper Engineer.
Beauty and the Beast: A Pop-up Book of the Classic Fairy Tale by Robert Sabuda. Little Simon, 2010.

Robert Sabuda, Paper Engineer.
Chanukah Lights by Michael J. Rosen. Robert Sabuda, paper engineer. Additional
 design work by Simon Arizpe and Shelby Arnold. Candlewick Press, 2011.

Robert Sabuda, Matthew Reinhart, Paper Engineers.
 Encyclopedia Mythologica: Dragons & Monsters by Robert Sabuda and Matthew
 Reinhart. Walker Books, 2011.

Santoro Graphics, Inc., Paper Engineering.
 Wild Oceans: A Pop-Up Book with Revolutionary Technology by Lucio Santoro
 and Meera Santoro. Little Simon, 2010.

Yevgeniya Yeretskaya, Paper Engineer.
 Snowflakes: A Pop-Up Book by Jenn Chushcoff. Yevgeniya Yeretskaya, illustrator
 and paper engineer. Jumping Jack Press, 2011.

On being a paper engineer…

*"I'd say the most exciting thing about being a paper engineer is having the
chance to figure out new or better ways to solve problems. There are a lot of
opportunities to be original, mostly because so few people do what we do.*

*"I learned on the job. I started in production, working with die lines and putting
things together. More experienced engineers that I've worked for or worked
with have been very generous with their knowledge. I've also learned a lot
from talking to production workers at the factories. I try to experiment and
make a point of learning from my mistakes.*

*"The community aspect of the Movable Book Society is very important (to my
career). This job can be very isolating. Getting to know other engineers and
collectors has been invaluable. The fact that people out there think about and
care deeply about what I do, helps me to stay motivated and inspired."*

 Sam Ita, Paper Engineer

Marion Bataille, Paper Engineer

Marion Bataille is a French graphic designer, paper engineer and children's book author. She graduated from the Ecole supérieure d'arts graphiques in Paris and later worked as artistic director for the magazine *Télérama.* Since her internationally best-selling *ABC3D* was published, Bataille continues to explore visual approaches to typography through the publication of *10* (2011), *Numero* (2013) and *AOZ: ou l'atelier du typographe* (2016).

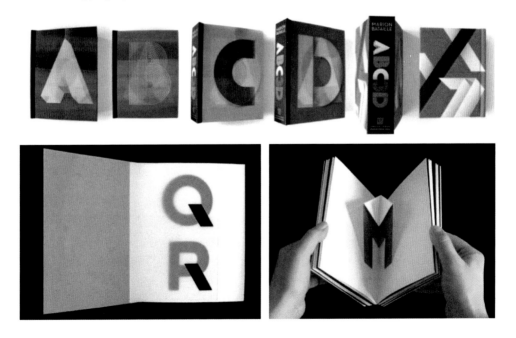

ABC3D by Marion Bataille. Tara Books, 2008. *"A-plus for drama and innovation,"* declared *Publishers Weekly*.

2010 MEGGENDORFER PRIZE FINALISTS

Announced at the 2010 MBS Conference in Portland, Oregon
September 23-25, 2010

Andrew Baron, Renee Jablow, Gene Vosough, Paper Engineers.
Birdscapes: A Pop-Up Celebration of Birdsongs in Stereo Sound by Miyoko Chu, with the Cornell Lab of Ornithology, illustrated by Julia Hargreaves. Andrew Baron, Renee Jablow, Gene Vosough, paper engineers. Chronicle Books, 2008.

Marion Bataille, Paper Engineer.
ABC3D by Marion Bataille. Roaring Brook Press, 2008.

Sally Blakemore, Paper Engineer.
NASCAR Pop-up: A Guide to the Sport by Sally Blakemore, illustrated by Doug Chezem. Sally Blakemore, design and paper engineering. Gibbs Smith, 2009.

David A. Carter, Paper Engineer.
Horton Hears a Who Pop-up! By Dr. Seuss. David A. Carter, paper engineer. Robin Corey Books, 2008.

White Noise: A Pop-Up Book for Children of All Ages by David A. Carter. Little Simon, 2009.

Yellow Square: A Pop-Up Book for Children of All Ages by David A. Carter. Little Simon, 2008.

Corina Fletcher, Paper Engineer.
Charlie and Lola: I Am Not Sleepy and I Will Not Go to Bed by Lauren Child. Corina Fletcher, paper engineer. Candlewick Press, 2008.

Bruce Foster, Paper Engineer.
In the Beginning: The Art of Genesis – A Pop-Up Book by Chuck Fischer. Text by Curtis Flowers. Bruce Foster, paper engineer. Little Brown, 2008.

Visionaire No. 55 : Surprise. Collection of pop-up books highlighting artwork by Sophie Calle, Andreas Gursky, Cai Guo-Qiang, Steven Klein, Yayoi Kusama, Alasdair McLellan, Steven Meisel, Guido Mocafico, Nicola Formichetti/Gareth Pugh, Sølve Sundsbø and Mario Testino. Bruce Foster, paper engineer. Visionaire Publishing, 2008.

Patricia Fry, Paper Engineer.
 The Nutcracker: A Pop-up Book – Adapted from the Classic Tale by E.T. A. Hoffmann. Patricia Fry, paper engineer. Katherine Tegen Books, 2008.

David Hawcock, Paper Engineer.
 The Pop-Up Book of Ships by Eric Kentley, illustrated by Garry Walton. David Hawcock, paper engineer. Universe Publishing, 2009.

Sam Ita, Paper Engineer.
 20,000 Leagues Under the Sea: A Pop-Up Book by Sam Ita. Sterling Publishing, 2008.

Gérard Lo Monaco, Paper Engineer.
 The Little Prince Deluxe Pop-Up Book by Antoine de Saint-Exupéry. Translated from French by Richard Howard. Gérard Lo Monaco, Paper Engineer. HMH Books, 2009.

Ray Marshall, Paper Engineer.
 The Castaway Pirates: A Pop-Up Tale of Bad Luck, Sharp Teeth, and Stinky Toes by Ray Marshall, illustrated by Wilson Swain. Design by Katie Jennings. Ray Marshall, paper engineer. Chronicle Books, 2008.

Matthew Reinhart, Paper Engineer.
 A Pop-Up Book of Nursery Rhymes by Matthew Reinhart. Little Simon, 2009.

Robert Sabuda, Paper Engineer.
 Peter Pan: A Pop-Up Adaptation of J.M. Barrie's Original Tale by J.M.Barrie. Robert Sabuda, paper engineer. Little Simon, 2008.

Robert Sabuda, Matthew Reinhart, Paper Engineers.
 Brava, Strega Nona! A Heartwarming Pop-up Book by Tomie dePaola. Robert Sabuda and Matthew Reinhart, paper engineers. G.P. Putnam's Sons, 2008.

 Encyclopedia Mythologica: Fairies and Magical Creatures by Robert Sabuda and Matthew Reinhart, paper engineers. Candlewick Press, 2008.

Santoro Graphics, Inc., Paper Engineering.
 Predators: A Pop-Up Book with Revolutionary Technology by Lucio Santoro and Meera Santoro. Little Simon, 2008.

Rodger Smith, Paper Engineer.
 Mad About Politics: An Outrageous Pop-Up Political Parody! By Alfred E. Neuman. Rodger Smith, paper engineer. Insight Editions, 2008.

After a college career focused on the sciences, Matthew Reinhart studied industrial design at Pratt Institute and soon after discovered his true calling—creating pop-up books. His titles include *Frozen: A Pop-Up Fairy Tale*, *Transformers: The Ultimate Pop-Up Universe* and *Lego: A Journey Through the Lego Universe,* to name a few.

Matthew Reinhart,
Paper Engineer
Photo by Larry D. Moore, CC BY-SA 4.0

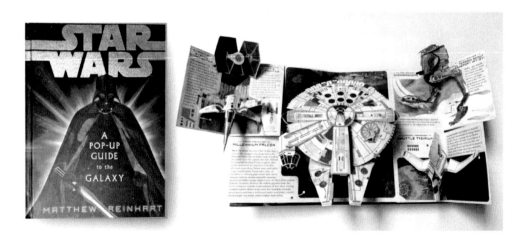

Star Wars: A Pop-Up Guide to the Galaxy by Matthew Reinhart. Scholastic, 2007. New York Times columnist David Pogue wrote "...calling this sophisticated piece of engineering a "pop-up book" is like calling the Great Wall of China a partition." The book celebrates the iconic movie's 30th anniversary and includes 36 different pop-up displays. Luke Skywalker and Darth Vader even face off wielding light sabers that actually light up!

2008 MEGGENDORFER PRIZE FINALISTS

Announced at the MBS Conference in Washington, D.C.
September 18-20, 2008

David A. Carter, Paper Engineer.
600 Black Spots: A Pop-Up Book for Children of All Ages by David A. Carter. Little Simon, 2007.

Blue 2: A Pop-Up Book for Children of All Ages by David A. Carter. Little Simon, 2006.

James Roger Diaz, Paper Engineer.
Popigami: When Everyday Paper Pops! by James Roger Diaz, illustrated by Francesca Diaz. Orchard Books, 2007.

Corina Fletcher, Paper Engineer.
Charlie and Lola's I Will Never Not Ever Eat a Tomato: Pop-Up by Lauren Child. Corina Fletcher, paper engineer. Candlewick Press, 2007.

Bruce Foster, Paper Engineer.
Christmas Around the World: A Pop-Up Book by Anne Newgarden, illustrated by Chuck Fischer. Bruce Foster, paper engineer. Little Brown and Company, 2007.

Halloween at the Zoo: a Pop-Up Trick-or-Treat Experience by George White, illustrated by Jason O'Malley. Designed by Grace Co and Monika Brandrup. Bruce Foster, paper engineer. Jumping Jack Press, 2007.

The Pop-Up Book of Celebrity Meltdowns by Heather Havrilesky, illustrated by Mick Coulas. Bruce Foster, paper engineer. Melcher Media, 2006.

Sam Ita, Paper Engineer.
Moby-Dick: A Pop-Up Book by [Herman Melville]. Sam Ita, illustrator and paper engineer. Sterling Publishing, 2007.

Kees Moerbeek, Paper Engineer.
Alfred Hitchcock: The Master of Suspense: A Pop-Up Book by Cindy Eng. Kees Moerbeek, paper engineer. Simon & Schuster, 2006.

Chuck Murphy, Paper Engineer.
Graceland: An Interactive Pop-Up Tour by Jason Rekulak. Foreword by Priscilla Presley. Chuck Murphy, paper engineer. Quirk Books, 2006.

Kyle Olmon, Paper Engineer.
Castle: Medieval Days and Knights text and paper engineering by Kyle Olmon, illustrated by Tracy Sabin. Orchard Books, 2006.

David Pelham, Paper Engineer.
Trail: Paper Poetry by David Pelham. Little Simon, 2007.

Matthew Reinhart, Paper Engineer.
The Jungle Book by Rudyard Kipling. Matthew Reinhart, paper engineer. Additional design by Michael Caputo, Kyle Olmon, and Jessica Tice. Little Simon, 2006.

Mommy? by Arthur Yorinks, illustrated by Maurice Sendak. Matthew Reinhart, paper engineer. Scholastic, 2006.

Star Wars: A Pop-Up Guide to the Galaxy. Text and art based on the Star Wars motion pictures, Lucasfilm, Ltd. Matthew Reinhart, paper engineer. Scholastic, 2007.

Robert Sabuda, Matthew Reinhart, Paper Engineers.
Encyclopedia Prehistorica: Mega Beasts by Robert Sabuda and Matthew Reinhart. Candlewick Press, 2007.

Encyclopedia Prehistorica: Sharks by Robert Sabuda and Matthew Reinhart. Candlewick Press, 2006.

Santoro Graphics, Inc., Paper Engineering.
Journey to the Moon: A Roaring, Soaring Ride! by Lucio Santoro and Meera Santoro. Little Simon, 2007.

Iain Smyth, Paper Engineer.
Alive: The Living, Breathing Human Body by Anita Ganeri, illustrated by Philip Fitzgerald. Mark Lloyd, designer. Iain Smyth, paper engineer. DK Publishers, 2007.

Ron van der Meer, Graham Brown, Paper Engineers.
How Many: Spectacular Paper Sculptures: A Pop-Up by Ron van der Meer. Text by Yvette Lodge. Graphics by Tim Dyer. Ron van der Meer and Graham Brown, paper engineers. Robin Corey Books, 2007.

David A. Carter, Paper Engineer
Photo by Keith Sutter

Utah native David A. Carter studied illustration and art at Utah State University before moving to Los Angeles in 1980. He worked at various graphic design jobs before going to work for Waldo Hunt at Intervisual Communications Inc. While there Carter learned paper engineering and pop-up book making from ICI creative director James Roger Diaz and craftsmen David Pelham, Jan Pieńkowski and John Strejan. Carter created *How Many Bugs in a Box?* at ICI. Since 1987, Carter has worked in his own business and created more than 100 pop-up books with over 6.5 million worldwide unit sales.

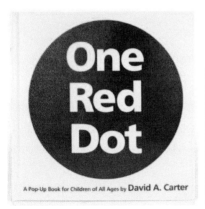

One Red Dot: A Pop-Up for Children of All Ages by David A. Carter. Little Simon, 2005. Readers are challenged to find a single red dot in the book's cacophony of form, color, movement, and even, sound.

2006 MEGGENDORFER PRIZE FINALISTS

Announced at the MBS Conference in Chicago, Illinois
September 14-16, 2006

David A. Carter, Paper Engineer.
One Red Dot: A Pop-Up for Children of All Ages by David A. Carter. Little Simon, 2005.

Quintessential Disney: A Pop-Up Gallery of Classic Disney Moments by Robert Tieman, illustrated by Toby Bluth. Katie LeClercq Hackworth, designer. David A. Carter, paper engineer. Disney Editions, 2005.

Bruce Foster, Paper Engineer.
Peanuts: A Pop-Up Celebration by Charles Schulz, illustrated by Paige Braddock. Bruce Foster, paper engineer. Little Simon, 2004.

David Hawcock, Paper Engineer.
Christmas in New York: A Pop-Up Book by Chuck Fischer. Text by Anne Newgarden. David Hawcock, paper engineer. Bulfinch Press, 2005.

White House Pop-Up Book by Chuck Fischer. David Hawcock, paper engineer. Universe Publishing, 2004.

Kees Moerbeek, Paper Engineer.
The Girl Who Loved Tom Gordon: A Pop-Up Book by Stephen King with text adapted by Peter Abrahams, illustrated by Alan Dingman. Kees Moerbeek, paper engineer. Little Simon, 2004.

Matthew Reinhart, Paper Engineer.
The Ark: A Pop-Up by Matthew Reinhart. Little Simon, 2005.

Cinderella: A Pop-Up Fairy Tale by Matthew Reinhart. Additional design by Kyle Olmon and Michael Caputo. Little Simon, 2005.

Robert Sabuda, Matthew Reinhart, Paper Engineers.
Encyclopedia Prehistorica: Dinosaurs by Robert Sabuda and Matthew Reinhart. Candlewick Press, 2005.

Robert Sabuda, Paper Engineer.
America the Beautiful: A Pop-Up Book by Robert Sabuda. Little Simon, 2004.

Winter's Tale: An Original Pop-Up Journey by Robert Sabuda. Little Simon, 2005.

Andrew Baron has always desired to delight and excite the reader's imagination. He is best known for advancing the art of the movable book, as popularized by Lothar Meggendorfer. Baron's paper design style is strongly influenced by his mechanical background, starting at the age of 12 with the restoration of antique phonographs, early radios, and as time unfolded, with typewriters, jukeboxes and music boxes.

After 21 years of machine restoration, Baron began his pop-up career working at book packager White Heat Ltd and Sally Blakemore's Arty Project Studio.

Andrew Baron, Paper Engineer

Baron was technical consultant for Brian Selznick's *The Invention of Hugo Cabret* and later restored the famous 1795 Maillardet automaton, the inspiration for the book. Today Baron's career encompasses high quality clock repair and paper engineering.

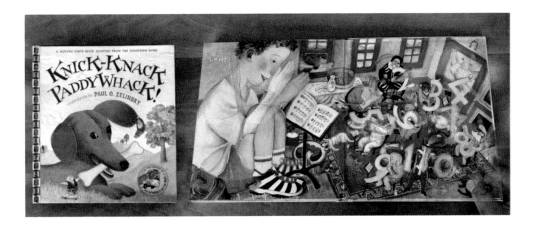

Knick-Knack Paddywhack!: Adapted from the song "This Old Man" by Paul O Zelinsky. Andrew Baron, paper engineer. Dutton Children's Books 2002. This award-winning movable wonder has 200 movable parts, 300 glue points, 15 lift-the-flaps, and on the last spread above, pulling a single tab animates the spread in ten locations... simultaneously!

2004 MEGGENDORFER PRIZE FINALISTS

Announced at the 2004 MBS Conference in San Diego, California
September 30 – October 4, 2004

Andrew Baron, Paper Engineer.
Knick-Knack Paddywhack: A Moving Parts Book, adopted from the counting song "This Old Man" and illustrated by Paul O. Zelinsky. Andrew Baron, paper engineer. Dutton Children's Books, 2002.

David A. Carter, Paper Engineer.
Chanukah Bugs: A Pop-Up Celebration by David A. Carter. Little Simon, 2002.

James Roger Diaz, Paper Engineer.
J. Otto Seibold's Alice in (Pop-up) Wonderland: With Original Text from the Lewis Carroll Classic. Illustrated by J. Otto Seibold. James Roger Diaz, paper engineer. Orchard Books, 2003.

Keith Finch, Paper Engineer.
Frank Lloyd Wright in Pop-Up by Iain Thomson, pop-up artwork by Andrew Crowson. Keith Finch, paper engineer. PRC Publications, 2002.

Bruce Foster, Paper Engineer.
Creativity: The Flowering Tornado: A Pop-Up Gallery by Ginny Ruffner. Bruce Foster, paper engineer. Montgomery Museum of Fine Arts, 2003.

David Hawcock, Paper Engineer.
Great American Houses and Gardens by Chuck Fischer. David Hawcock, paper engineer. Universe Publishing, 2002.

The Country Music Pop-Up Book by the staff of the Country Music Hall of Fame and Museum. David Hawcock, paper engineer. Universe Publishing, 2003.

Dennis K. Meyer, Paper Engineer.
Harry Potter and the Chamber of Secrets: A Deluxe Pop-Up Book based on story by J. K. Rowling, illustrated by Joe Vaux and design by Treesha Runnells. Dennis K. Meyer, paper engineer. Scholastic, 2002.

Massimo Missiroli, Paper Engineer.
Pinocchio: A Pop-Up Book based on the fairy tale by Carlo Collodi, illustrated by Lucia Salemi. Massimo Missiroli, paper engineer. Emme Edizioni, 2002.

Kees Moerbeek, Paper Engineer.
The Diary of Hansel and Gretel by Kees Moerbeek. Little Simon, 2002.

Kees Moerbeek, Paper Engineer.

Raggedy Ann and Andy and the Camel with the Wrinkled Knees by Johnny Gruelle. Text adapted by Melissa Eisler. Kees Moerbeek, paper engineer. Little Simon, 2003.

Pamela Pease, Paper Engineer.

Macy's On Parade! A Pop-Up Book for Children of All Ages by Pamela Pease, design and paper engineer. Andrew Baron, consulting paper engineer. Paintbox Press, 2002.

Matthew Reinhart, Paper Engineer.

Animal Popposites: A Pop-Up Book of Opposites by Matthew Reinhart. Little Simon, 2002.

Paul Stickland, Paper Engineer.

Big Dig: A Pop-Up Construction! by Paul Stickland. Ragged Bears, 2002.

On being a paper engineer…

"I am largely self-taught through a whole lot of trial and error. I worked alongside Keith Finch, who had been an aeronautical engineer. We had many conversations and were able to bounce ideas off each other. He became a paper engineer too. I see paper engineering as an extension of book design, and treat it like any other tool or skill that helps tell a story.

"People are still amazed at movable books. Some thirty years after my first moveable books, I am excited about reviving and adapting them for a new audience. I've worked on just under twenty moveable books so far and probably have another twenty waiting in the wings. I've been blessed with the fact that more than 2 million pairs of eyes around the world saw and enjoyed them. It's an achievement that will stay with me forever."

Ken Wilson-Max, Paper Engineer

Robert Sabuda, Paper Engineer

Robert Sabuda is a graduate of Pratt Institute, where he later became an associate professor. Sabuda began a paper engineering program at Pratt that continues to encourage the next generation of paper artists.

Sabuda is a two-time recipient of the *New York Times* Best Illustrated Book Award and has over five million books in print. He is the co-creator of the *Encyclopedia Prehistorica* pop-up trilogy, which has been translated into over 25 languages worldwide.

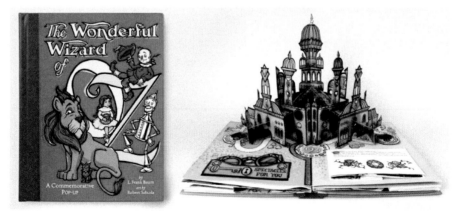

The Wonderful Wizard of Oz: A Commemorative Pop-Up. A Classic Collectible by L Frank Baum. Robert Sabuda, paper engineer. Little Simon, 2000. This magical pop-up book includes a spinning cyclone, a floating hot-air balloon and special tinted glasses for viewing the glimmering Emerald City!

Kees Moerbeek,
Paper Engineer
1st Runner Up Honors

Kees Moerbeek was born in a small village in the south west of the Netherlands. He is the son of a cobbler and youngest of six children. In 1978, he entered the School of Decorative Arts of Arnhem and specialized in Children's Illustration. Here he created his first pop-up projects, including the initial version of the Roly Poly box, without the pop-ups.

At the 1983 Frankfurt Bookfair, Moerbeek showed some of his foldable paper projects to representatives from Intervisual Communications (ICI), the leading packagers of pop-up books to positive results.

In 1984, Waldo Hunt, ICI owner, offered him a job. Moerbeek worked for ICI for twelve years and produced over fifty pop-up books in cooperation with paper engineers David A. Carter, Jim Deesing, James Roger Diaz, Dick Dudley, Keith Moseley, Peter Seymour and John Strejan. Since 1998, Moerbook has been an independent book-designer and artist. In 2010, he created the largest pop-up book (6 x 4 meters open) for a Pearle Opticians commerical. It was certified by the Guiness Book of World Records. Today, he continues to design books and creates Jönköping Matchbox miniature furniture.

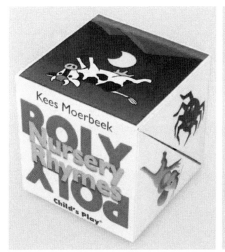 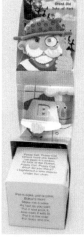 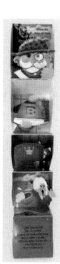

Roly Poly Nursery Rhymes: A 3D Cube Book by Kees Moerbeek. Child's Play, 2000.
Unfold ten different pop-up rhymes from Pat-a-cake, Pat-a-cake to Humpty Dumpty.

2nd Runner Up Honors to:

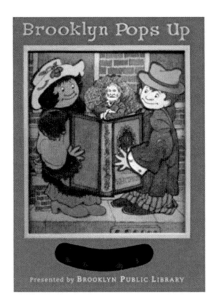

Maurice Sendak
for movable Brooklyn children on the cover

David A. Carter, **Tor Lokvig**
for Brooklyn Brownstones

Bruce Foster
for Grand Army Plaza and Brooklyn Public Library

Robert Sabuda
for the Brooklyn Museum of Art and Brooklyn Children's Museum

Ken Wilson-Max, **Keith Finch**
for the Brooklyn Botanic Garden

Biruta Akerbergs Hansen
for Prospect Park and the Carousel

Iain Smyth for the Brooklyn Bridge

Kees Moerbeek, **Carla Dijs**
for the Flavors of Brooklyn

Chuck Murphy for Coney Island

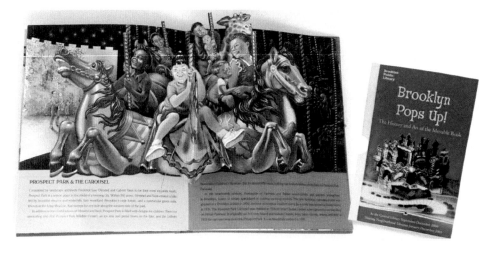

The publication of *Brooklyn Pops Up* coincided with the exhibition "Brooklyn Pops Up: The History and Art of the Movable Book." Concept by Ann Montanaro [Staples], Ellen G. K. Rubin and Robert Sabuda. Text by Pamela Thomas and Chani Yammer, designer. 16-page miniature catalog with exhibition checklist included. Brooklyn Public Library, Little Simon, 2000. A trade edition was available without a catalog. A deluxe edition included a linen slipcase with tipped-in signatures.

2002 Meggendorfer Prize Finalists

Announced at the MBS Conference in Milwaukee, Wisconsin
September 19-21, 2002

Steve Augarde, Paper Engineer.
Vroom! Vroom! A Pop-Up Race to the Finish! by Steve Augarde. Little Brown, 2000.

When I Grow Up: A Pop-Up Book! by Steve Augarde. Grosset & Dunlap, 2000.

Andrew Bennett, Paper Engineer.
Dr Optics Amazing Illusions: With 3-D Glasses and Fantastic Pop-Ups! by Andrew Bennett, illustrated by Simon Cooper and Kevin Hauff. Andrew Bennett, paper engineer. Macmillan Children's Books, 2001.

David A. Carter, Paper Engineer.
Flapdoodle Dinosaurs: A Colorful Pop-Up Book by David A. Carter. Little Simon, 2001.

David A. Carter, Carla Dijs, Keith Finch, Bruce Foster, Biruta Akerbergs Hansen, Tor Lokvig, Kees Moerbeek, Chuck Murphy, Robert Sabuda, Iain Smyth, Ken Wilson-Max, Paper Engineers.
Brooklyn Pops Up. Text by Pamela Thomas. Contributors include illustrator Maurice Sendak and above-listed paper engineers. Brooklyn Public Library, Little Simon, 2000.

Nick Denchfield, Paper Engineer.
The Tickle Book: with Pop-Up Surprises by Ian Whybrow, illustrated by Axel Scheffler. Nick Denchfield, paper engineer. Macmillan Children's Books, 2000.

Richard Ferguson, Paper Engineer.
Ruby The Ballet Star: A Twirly-Whirly Pop-up Book by Harriet Griffey, illustrated by Anne Holt. Richard Ferguson, paper engineer. Tango Books, 2000.

Richard Ferguson, Mat Johnstone, Paper Engineers.
Who Will You Meet on Scary Street? Nine Pop-Up Nightmares by Christine Tagg, illustrated by Charles Fuge. Mike Jolley, designer. Richard Ferguson and Mat Johnstone, paper engineers. Little Brown, 2001.

Bruce Foster, Paper Engineer.
Little Red Riding Hood. A Classic Collectible Pop-up by Marjorie Priceman. Bruce Foster, paper engineer. Little Simon, 2001.

Allen Hamilton, Paper Engineer.
Wakey Wakey, Nighty Night: A Slide-the-Spot Bedtime Book. by Sam Williams. Allen Hamilton, paper engineer. Scholastic Cartwheel Books, 2001.

David Hawcock, Paper Engineer.
The California Pop-Up Book. Contributions by David Hockney, Dennis Hopper, Graham Nash, Carolyn See, and Keven Starr. David Hawcock, paper engineer. The Los Angeles County Museum of Art and Universe Publications, 2001.

Fashion – á la Mode: The Pop-Up History of Costumes and Dresses by Isabelle de Borchgrave. Text by Dorothy Twining Globus. David Hawcock, paper engineer. Universe, 2001.

Hawcock Books, Paper Engineering.
The Moon Book: A Lunar Pop-Up Celebration by Arlene Seymour. Hawcock Books, design and paper engineering. Universe Publishing, 2001.

Charlotta Janssen, Paper Engineer.
The Secret of Three Butterpillars: A Never-Ending Tale. A Tumbling Book. by Charlotta Janssen. Workman Publications, 2001.

Mat Johnstone, Paper Engineer.
The Book of Greek Myths: Pop-Up Board Games. Brian Lee, illustrator. Concept by David West. Mat Johnstone, paper engineer. Tango Books, 2000.

Jonathan Lambert, Paper Engineer.
The Baboon's Bottom: A Crazy Surprise Pop-Up Book by Keith Faulkner. Jonathan Lambert, illustrator and paper engineer. Prospero Books, 2000.

Kees Moerbeek, Paper Engineer.
Roly Poly Nursery Rhymes: A 3D Cube Book by Kees Moerbeek. Child's Play, 2000.

The Spooky Scrapbook by Kees Moerbeek. Little Simon, 2000.

David Pelham, Paper Engineer.
A Piece of Cake by David Pelham. Handprint Books, 2000.

Anton Radevsky, Paper Engineer.
The Pop-Up Book of Spacecraft by Anton Radevsky. Könemann Verlagsgesellschaft, 2000.

Stephen Ramsay, Paper Engineer.
Mighty Machines: A Pop-Up Book by Mary Bjelobrk, illustrated by Rob Paes. Kaye Binns-McDonald, designer. Stephen Ramsay, paper engineer. Grandreams, 2001.

Rives, Paper Engineer.
> *If I Were A Polar Bear* by Rives. Piggy Toes Press, 2001.

Robert Sabuda, Paper Engineer.
> *The Wonderful Wizard of Oz: A Commemorative Pop-Up by* Robert Sabuda. Based on the classic novel by L. Frank Baum. Additional design work by Matthew Reinhart. Little Simon, 2000.

Keri Smith, Paper Engineer.
> *Cinderella: Story in a Box* series, retold and illustrated by Keri Smith. Chronicle Books, 2001.

Iain Smyth, Paper Engineer.
> *Monster Train* by Michael Ratnett, Illustrated by June Goulding. Iain Smyth, paper engineer. Orchard Books, 2000.

Nominated with uncredited paper engineer.
> *Sad Doggy* by Jennifer Lawrence, illustrated by Timothy Basil Ering. Lynette Ruschak, concept. Melanie Random, designer. Piggy Toes Press, 2001.

On being a paper engineer…

"I genuinely feel like I've been a paper engineer since the 4th grade. The same thing that excites me now about the craft is the same thing that excited me then: Paper is flat. I want to make it not flat anymore.

"I would consider David A. Carter a mentor, and a very generous one. Rodger Smith was head of Paper Engineering when I started at Intervisual Books, and he shepherded me through two solid years of learning the craft. Waldo Hunt had a superb collection of Lothar Meggendorfer books so: Herr Meggendorfer also influenced me."

Rives, Paper Engineer

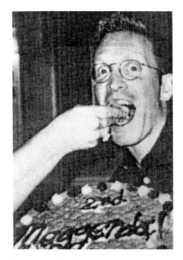

Robert Sabuda, Paper Engineer
Sampling a giant-sized cookie with "2nd Meggendorfer Prize" written on it.
Source: *Movable Stationery, vol. 8, no. 4, Nov. 2000, p. 18.*

Robert Sabuda grew up in Pinckney, Michigan. His school teachers knew he loved art, and would ask him to create their bulletin boards. Sabuda covered the bulletin boards with cut paper collages. At home, he created homemade books filled with his own illustrations. During a boyhood visit to the dentist, Sabuda opened his first pop-up book...and was hooked! Today, Sabuda is a two-time recipient of the *New York Times* Best Illustrated Book Award and has over five million books in print.

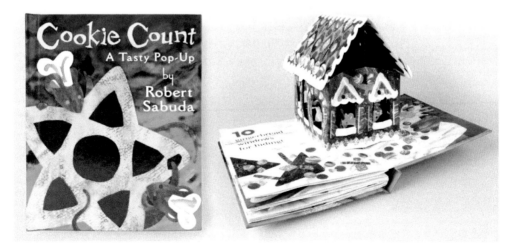

Cookie Count: A Tasty Pop-Up by Robert Sabuda, author, illustrator and paper engineer. Little Simon, 1997. Count to ten with this tasty collection of confectionary creations.

2000 MEGGENDORFER PRIZE FINALISTS

Announced at the 2000 MBS Conference in New York, New York
September 21 – 23, 2000

Andrew Baron, Sally Blakemore, Paper Engineers.
Circus! A Pop-Up Adventure by Meg Davenport and Lisa V. Werenko, illustrated by Meg Davenport. Andrew Baron and Sally Blakemore, paper engineers. Little Simon, 1998.

Andrew Baron, Paper Engineer.
The Hobbit: A 3-D Pop-Up Adventure based on the book by J. R. R. Tolkien, illustrated by John Howe. Concept and design by Mike Haines for Threefold. Andrew Baron, paper engineer. Harper Festival, 1999.

David A. Carter, Paper Engineer.
The 12 Bugs of Christmas: A Pop-Up Christmas Counting Book by David A. Carter. Little Simon, 1999.

Bed Bugs: A Pop-Up Bedtime Book by David A. Carter. Little Simon, 1998.

Bugs in Space: A Pop-Up Journey by David A. Carter. Little Simon, 1997.

David A. Carter's Curious Critters: A Pop-Up Menagerie by Alan Benjamin. David A Carter, paper engineer. Little Simon, 1998.

David A. Carter, James Roger Diaz, Paper Engineers.
The Elements of Pop-Up: A Pop-Up Book for Aspiring Paper Engineers by David A. Carter and James Roger Diaz. Leisa Bentley, assistant designer and illustrator. Keith Sutter, photographer. David A. Carter and James Roger Diaz, paper engineers. Little Simon, 1999.

Corina Fletcher, Paper Engineer.
Mathsmaster 5+ by Ron van der Meer. Corina Fletcher, paper engineer. Konemann, 1999.

Eugenia Guzmán, Paper Engineer.
Our Lady of Guadalupe by Francisco Serrano, illustrated by Felipe Dávalos. Translated by Haydn Raulinson. Eugenia Guzmán, paper engineer. Groundwood Books, 1998.

David Hawcock, Paper Engineer.

Monster Talk Pop-Up by Nicholas Tulloch, illustrated by George Fryer and Lee Montgomery. David Hawcock, paper engineer. Electric Paper, 1998.

The New York Pop-Up Book with Marie Salerno, editor and Arthur Gelb, consulting editor. Design by Bob Bass. David Hawcock, paper engineer. Universe, 1999.

Richard Hawke, Paper Engineer.

Snappy Little Colors: Discover a Rainbow of Colors by Kate Lee and Caroline Repchuk, illustrated by Derek Matthews. Richard Hawke, paper engineer. Millbrook Press, 1998.

Mark Hiner, Corina Fletcher, Paper Engineers.

The Architecture Pack: A Unique, Three-Dimensional Tour of Architecture Over The Centuries: What Architects Do, How They Do It, And The Great Buildings They Have Given Us Around The World by Ron van der Meer and Deyan Sudjic, illustrated by Paul Crompton. Mark Hiner and Corina Fletcher, paper engineers. Alfred A. Knopf, 1997.

Damian Johnston, Paper Engineer.

The Amazing Pop-Up Music Book by Kate Petty, illustrated by Jennie Maizels. Damian Johnston, paper engineer. Dutton Children's Books, 1999.

I Can Too! An Elmer Pop-Up Book by David McKee. Damian Johnston, paper engineer. Lothrop, Lee & Shepard Books, 1997.

Jane McTeigue, Paper Engineer.

Alphabet Zoo: A Pop-Up ABC Book by Lynette Ruschak, illustrated by May Rousseau. Jane McTeigue, paper engineer. Envision Publishing, 1997.

Kees Moerbeek, Paper Engineer.

Santa's Surprise!: A Pop-Up Rebus Book by Dawn Bentley. Jim Deesing, art director. Kees Moerbeek, paper engineer. Piggy Toes Press, 1998.

Frederic Moret, Paper Engineer.

Our World: An Unfolding Journey Around the Earth by François Michel, illustrated by Philippe Mignon. Translated by Käthe Roth. Frederic Moret, paper engineer/maquettes. Barnes & Noble Books, 1999.

Ivan Moscovich, Paper Engineer.

The Think Tank: A Fantastic Collection of 3-D and Pop-Up Games and Puzzles by Ivan Moscovich. DK Inc, 1998.

Keith Moseley, Paper Engineer.

The Bible Alphabet: A Pop-Up Book by Keith Moseley. Scriptures from the Holy Bible, the New International Version. Design by Michael J. Young. Broadman & Holman Publishers, 1998.

Chuck Murphy, Paper Engineer.

Chuck Murphy's Black Cat, White Cat: A Pop-Up Book of Opposites by Chuck Murphy. Little Simon, 1998.

Chuck Murphy's Color Surprises: A Pop-Up Book by Chuck Murphy. Little Simon, 1997.

Jack and the Beanstalk: Illustrated in Three Dimensions. Classic Collectible Pop-Up Series by Chuck Murphy. Hallmark Cards Gift Books. Little Simon, 1998.

Matthew Reinhart, Paper Engineer.

The Pop-Up Book of Phobias by Gary Greenberg, illustrated by Balvis Rubess. Matthew Reinhart, paper engineer. Rob Weisbach Books, 1999.

Rives, Paper Engineer.

The Consummate Cigar Book: A Three-Dimensional Reference Guide by Robert Kemp, illustrated by John Rowe. Kathryn Siegler, designer and Jim Dessing, art director. Rives, paper engineer. Pop-Up Press, 1997.

Robert Sabuda, Paper Engineer.

ABC Disney: An Alphabet Pop-Up by Robert Sabuda. Disney Press, 1998.

Cookie Count: A Tasty Pop-Up by Robert Sabuda. Little Simon, 1997.

The Movable Mother Goose by Robert Sabuda. Little Simon, 1999.

Heather Simmons, Olivier Charbonnel, Paper Engineers.

Masks: Spectacular Masks to Pop Up, Pull Out and Put On! by The Metropolitan Museum of Art. Miriam Berman, book designer. Heather Simmons and Olivier Charbonnel, paper engineers. DK Inc., 1997.

Rodger Smith, Paper Engineer.

Harley-Davidson: A Three-Dimensional Tribute to an American Icon by Jerry Hatfield and Dawn Bentley, with Jim Deesing, designer. Rodger Smith, paper engineer. Pop-Up Press, 1998.

Rodger Smith, Paper Engineer.

Heroes of Space: A Three-Dimensional Tribute to 40 Years of Space Exploration by D.C. Agle. Jim Deesing, designer. Rodger Smith, paper engineer. Intervisual Books, 1999.

Iain Smyth, Paper Engineer.

The Amazing Inventions of Professor Screwloose: With Real Science Experiments: A Pop-Up Mechanical Book by Iain Smyth. Envision Publishing, 1998.

Vicki Teague-Cooper, Paper Engineer.

Annie Ate Apples: A Lift-the-Flap, Pull-the-Tab, Turn-the-Wheel, Pop-Up Alphabet Book! by Lynette Ruschak, illustrated by Bonnie Matthews. Vicki Teague-Cooper, paper engineer. DK Ink, 1998.

Ron van der Meer, Paper Engineer.

The Formula One Pack: The Most Comprehensive Interactive 3-D Study on Motor Racing Ever! by Ron van der Meer and Adam Cooper. Ron van der Meer, paper engineer. Van der Meer Publishing, 1999.

Ron van der Meer, Mark Hiner, Paper Engineers.

The Kids' Art Pack: A Hands-on Exploration of Art For The Whole Family by Ron van der Meer and Frank Whitford, illustrated by Paul Crompton and Corina Fletcher. Ron van der Meer and Mark, paper engineers. Dorling Kindersley, 1998.

The Ultimate 3D Pop-Up Art Book: Discover Art Through 60 Great Masterpieces by Ron van der Meer and Frank Whitford. Ron van der Meer and Mark Hiner, paper engineers. Dorling Kindersley, 1997.

Antje von Stemm, Paper Engineer.

Nightmare Cafe by Alex Henry. Antje von Stemm, illustrator and paper engineer. Envision Publishing, 1998.

Nightmare Hotel by Alex Henry. Antje von Stemm, illustrator and paper engineer. Envision Publishing, 1997.

Ken Wilson-Max, Paper Engineer.

The Amazing People Circus by Ken Wilson-Max. David Bennett Books, 1997.

Jay Young, Paper Engineer.

The Art of Science: A Pop-Up Adventure in Art by Martin Jenkins. Jay Young, paper engineer. Candlewick Press, 1999.

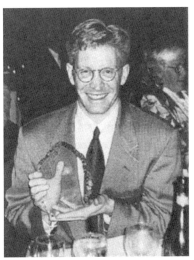

Robert Sabuda, Paper Engineer

The 1998 MBS conference was held at the Los Angeles Airport Hilton. Book artist Ed Hutchins presented "Toying with Books: Playing with Conventions." Paper engineer Chuck Murphy shared how he constructed the pop-up book *Jack and the Beanstalk*. There was a road trip to Intervisual Books to experience Waldo Hunt's Pop-up Museum. Collector Betty Traganza presented the history of Hallmark Cards pop-up books and three-dimensional products. Antiquarian book seller Howard Rootenberg spoke about flap-books. Ellen G. K. Rubin gave a glimpse of "Pop-ups for Grown-ups." Many happy hours were spent sharing paper folding techniques, browsing and buying at the Swap and Sell, and getting autographs from favorite paper engineers.

The last – and most anticipated – agenda item was the unveiling of the first Meggendorfer Prize for Best Paper Engineering, as voted by MBS members. Ann Montanaro [Staples] introduced the new honor and presented the etched award, designed by MBS member Adie Peña, to Robert Sabuda for *The Christmas Alphabet*.

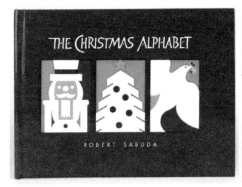
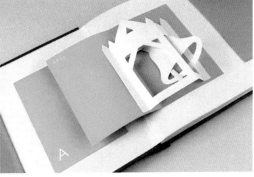

The Christmas Alphabet by Robert Sabuda. Orchard Books, 1994.

1998 MEGGENDORFER PRIZE FINALISTS

Announced at the 1998 MBS Conference in Los Angeles, California
April 30 – May 3, 1998

Helen Balmer, Paper Engineer.
 Jungle Adventure: A Pop-up Vacation, illustrations and paper engineering by Helen Balmer. Simon & Schuster Books for Young Readers, 1993.

Nick Bantock, Dennis K. Meyer, Paper Engineers.
 There Was An Old Lady designed and illustrated by Nick Bantock. Nick Bantock and Dennis K. Meyer, paper engineers. Viking Penguin, 1990.

 Jabberwocky: A Pop-Up Rhyme from Through the Looking Glass by Lewis Carroll, designed and illustrated by Nick Bantock. Nick Bantock and Dennis K. Meyer, paper engineers. Viking Penguin, 1991.

Maggie Bateson, Paper Engineer.
 A Victorian Dollhouse by Maggie Bateson and Herman Lelie. Maggie Bateson, paper engineer. St. Martin's Press, 1991.

Jonathan Biggs, Paper Engineer.
 The Pop-Up Kama Sutra by Vatsyayana, illustrated by Bob Robinson. Conceived and designed by Jonathan Biggs. Bonanza, 1984.

Diane Boatright, Paper Engineer.
 Dimensional Mazes: An Entirely New Way of Losing Yourself in a Book by David Pelham. Diane Boatright, paper engineer. Viking, 1989.

Jérôme Bruandet, Paper Engineer.
 Ten Bears in A Bed: A Pop-Up Counting Book by John Richardson. Jérôme Bruandet, paper engineer. Hyperion Books for Children, 1992.

David A. Carter, Paper Engineer.
 Alpha Bugs: A Pop-Up Alphabet by David A. Carter. Little Simon, 1994.

 How Many Bugs In A Box?: A Pop-Up Counting Book by David A. Carter. Simon & Schuster, 1988.

 Love Bugs by David A. Carter. Little Simon, 1995.

David A. Carter, David Pelham, Paper Engineers.
 Ben's Box by Michael Foreman. David A. Carter, David Pelham, paper engineers. Hodder and Stoughton Children's Books, 1986.

James Roger Diaz, Paper Engineer.
 Alice's Adventures in Wonderland by Lewis Carroll, illustrated by Jenny Thorne based on original illustrations by Sir John Tenniel, designed by John Strejan. James Roger Diaz, paper engineering. Delacorte Press, 1980.

 At the Zoo by Judith E. Rinard, illustrated by Warren Cutler. James Roger Diaz, paper engineer. National Geographic Society, 1992.

 The Bee by Beth B. Norden, illustrated by Biruta Akerbergs Hansen. Lynette Ruschak, book designer. James Roger Diaz, paper engineer. Stewart, Tabori & Chang, 1991.

 Lion Cubs and Their World by M. Barbara Brownell, illustrated by Biruta Akerbergs Hansen. James Roger Diaz, paper engineer. National Geographic Society, 1992.

 The Ultimate Bug Book: A Unique Introduction to the World of Insects in Fabulous, Full-Color Pop-Ups by Luise Woelflein, illustrated by Wendy Smith-Griswold. James Roger Diaz, paper engineer. Artists & Writers Guild Books, 1993.

 The Ultimate Ocean Book: A Unique Introduction to the World Under Water in Fabulous, Full-Color Pop-Ups by Maria-Mudd Ruth, illustrated by Virge Kask and Beverly Benner. James Roger Diaz, paper engineer. Artists & Writers Guild Books, 1995.

James Roger Diaz, David A. Carter, David Pelham, Paper Engineers.
 The Universe: A Three-Dimensional Study by Heather Couper and David Pelham, illustrated by Harry Willcock. James Roger Diaz, David A. Carter, and David Pelham, paper engineers. Random House, 1985.

James Roger Diaz, Tor Lokvig, Marcin Stajewski, Paper Engineers.
 Robots illustrated by Jan Pieńkowski, with assistance from Jane Walmsley, Kinga Pniewska, and Martine Forrest. James Roger Diaz, Tor Lokvig and Marcin Stajewski, paper engineers. Delacorte, 1981.

James Roger Diaz, John Strejan, Paper Engineers.
 Animals Showing Off by Jane R. McCauley, illustrated by Tony Chen, text by Jane Buxton. James Roger Diaz and John Strejan, paper engineers. National Geographic Society, 1988.

James Roger Diaz, John Strejan, Paper Engineers.
Creatures of the Desert World by Jennifer C. Urquhart, illustrated by Barbara Gibson. James Roger Diaz and John Strejan, paper engineers. National Geographic Society, 1987.

Strange Animals of the Sea, illustrated by Jerry Pinkney. James Roger Diaz and John Strejan, paper engineers. National Geographic Society, 1987.

James Roger Diaz, Rodger Smith, John Strejan, Paper Engineers.
Amazing Monkeys by Judith E Rinard, illustrated by Robert Hynes. James Roger Diaz, Rodger Smith and John Strejan, paper engineers. National Geographic Society, 1985.

Hide and Seek: A National Geographic Action Book, illustrated by Barbara Gibson. James Roger Diaz, John Strejan and Rodger Smith, paper engineers. National Geographic Society, 1985.

James Roger Diaz, Marcin Stajewski, Paper Engineers.
Dinner Time by Jan Pieńkowski. Text by Anne Carter. James Roger Diaz and Marcin Stajewski, paper engineers. Price Stern Sloan, 1991.

Vic Duppa-Whyte, Paper Engineer.
Halley's Comet Pop-Up Book by Patrick Moore and Heather Couper, illustrated by Paul Doherty. Vic Duppa-Whyte, paper engineer. Bonanza Pop-up Books, 1985.

The Royal Family Pop-Up Book by Patrick Montague-Smith, illustrated by Roger Payne. Vic Duppa-Whyte, paper engineer. Bounty Books, 1984.

Take Away Monsters by Colin Hawkins. Vic Duppa-Whyte, paper engineer. G. P. Putnam's Sons, 1984.

Vic Duppa-Whyte, David Rosendale, Paper Engineers.
The Human Body: With Three Dimensional, Movable Illustrations Showing the Workings Of The Human Body by Jonathan Miller, illustrated by Harry Wilcock. David Pelham, designer. Vic Duppa-Whyte and David Rosendale, paper engineers. Viking Press, 1983.

Bruce Foster, Paper Engineer.
Gutenberg's Gift: A Book Lover's Pop-Up Book by Nancy Willard, illustrated by Bryan Leister. Bea Jackson, designer. Bruce Foster, paper engineer. Harcourt Brace & Co., 1995.

David Hawcock, Paper Engineer.

Machines: A Book of Moving Pop-Ups by Tim Reeves, illustrated by Robert Andrew. David Hawcock, paper engineer. Philomel Books, 1993.

Mark Hiner, Corina Fletcher, Paper Engineers.

The Architecture Pack: A Unique, Three-Dimensional Tour of Architecture Over the Centuries: What Architects Do, How They Do It, and the Great Buildings They Have Given Us Around the World by Ron van der Meer and Deyan Sudjic, illustrated by Paul Crompton. Mark Hiner and Corina Fletcher, paper engineers. Alfred A. Knopf, 1997.

Ian Honeybone, Paper Engineer.

The Beatles: Musical Pop-Up by Rob Burt and Michael Wells, illustrated by Pete Campbell and Mike Peterkin. Ian Honeybone, paper engineer. Bonanza Pop-Up Books, 1985.

Christos Kondeatis, Paper Engineer.

Bible Stories from the Old Testament in Three Dimensions by Christos Kondeatis. Simon & Schuster Books for Young Readers, 1991.

Christos Kondeatis, Raymond Hawkey, Paper Engineers.

Evolution: The Story of the Origins of Humankind: A Three-Dimensional Book by Raymond Hawkey. Christos Kondeatis and Raymond Hawkey, paper engineers. G. P. Putnam's Sons, 1987.

Vojtěch Kubašta, Paper Engineer.

Moon Rocket: An All-Action Pop-Up Picture Storybook by Vojtěch Kubašta, illustrator and paper engineer. Brown Watson, 1986.

Claire Littlejohn, Paper Engineer.

Dinner with Fox: A 3-Dimensional Picture Book by Stephen Wyllie, illustrated by Korky Paul. Claire Littlejohn, paper engineer. Dial Books for Young Readers, 1990.

Tor Lokvig, Paper Engineer.

The Genius of Lothar Meggendorfer: A Movable Toy Book by Lothar Meggendorfer, with an Appreciation by Maurice Sendak, illustrated by Jim Deesing and Lothar Meggendorfer. Introduction by Waldo H. Hunt. David Pelham, designer. Tor Lokvig, paper engineer. Random House, 1985.

Haunted House by Jan Pieńkowski, assistant illustrator Jane Walmsley. Tor Lokvig, paper engineer. E.P. Dutton, 1979.

Tor Lokvig, John Strejan, Paper Engineers.

Monster Island by Ron van der Meer, assistant illustrator Atie van der Meer. Tor Lokvig and John Strejan, paper engineers. Holt, Reinhart and Winston, 1981.

Ray Marshall, Paper Engineer.

Cats Up: Purring Pop-Ups by Ray Marshall and Korky Paul. Ray Marshall, paper engineer. Simon & Schuster, 1982.

The Crocodile and the Dumper Truck: A Reptilian Guide to London: A Pop-Up Book by Sara Sharpe, illustrated by Korky Paul. Ray Marshall, paper engineer. Atheneum, 1982.

Dennis K. Meyer, Paper Engineer.

Kubla Khan: A Pop-Up Version of Coleridge's Classic by Samuel Taylor Coleridge, illustrated by Nick Bantock. Barbara Hodgson, designer. Dennis K. Meyer, paper engineer. Viking, 1994.

Dennis K. Meyer, José R. Seminario, Paper Engineers.

Golf-o-Rama: The Wacky Nine Hole Pop-Up Mini-Golf Book, illustrated by Bill Mayer. Jim Dessing, designer. Dennis K. Meyer and José R. Seminario, paper engineer. Hyperion Books for Children, 1994.

Kees Moerbeek, Paper Engineer.

Oh No, Santa! A Pop-Up Book by Kees Moerbeek. Price Stern Sloan, 1991.

Who's Peeking at Me? A Pop-Up Book by Kees Moerbeek. Price Stern Sloan, 1988.

Kees Moerbeek, Carla Dijs, Paper Engineers.

Six Brave Explorers: A Pop-Up Book by Kees Moerbeek and Carla Dijs. Price Stern Sloan, 1988.

Keith Moseley, Paper Engineer.

Gardens of Delight: A Pop-Up Anthology of Romantic Verse & Paper Flowers, illustrated by Robert Nicholls. Keith Moseley, paper engineer. Harry N. Abrams Inc., 1997.

Giorgio's Village by Tomie dePaola. Keith Moseley, paper engineer. G. P. Putnam's Sons, 1982.

Hiawatha by Henry Wadsworth Longfellow. Keith Moseley, paper engineer. Philomel Books, 1988.

Keith Moseley, Paper Engineer.
King Arthur and The Magic Sword: Illustrated in Three Dimensions adopted by Howard Pyle, illustrated by John James. Keith Moseley, paper engineer. Dial Books for Young Readers, 1990.

The Poetry of Friendship: A Bouquet of Romantic Verse and Paper Flowers by Keith Moseley, creator and paper engineer, illustrated by Patricia Whittaker. Harry N. Abrams, Inc., 1992.

Keith Moseley, John Strejan, Paper Engineers.
The Naughty Nineties: A Saucy Pop-Up Book for Adults Only by Peter Seymour, illustrated by Börje Svensson. Concept by Lesley Kaiser. Keith Moseley and John Strejan, paper engineers. Price Stern Sloan, 1982.

Chuck Murphy, Paper Engineer.
Chuck Murphy's One to Ten Pop-Up Surprises! by Chuck Murphy. Little Simon, 1995.

David Pelham, Paper Engineer.
A is for Animals: 26 Pop-Up Surprises: An Animal ABC by David Pelham. Simon & Schuster, 1991.

Sam's Sandwich by David Pelham, illustrated by David Pelham and Harry Willock. Dutton Children's Books, 1991.

Ib Penick, Paper Engineer.
The Dwindling Party: A Pop-Up Book by Edward Gorey. Ib Penick, paper engineer. Random House, 1982.

The Story of the Statue of Liberty: With Movable Illustrated in Three Dimensions designed and paper engineered by Ib Penick, illustrated by Joseph Forte. Holt, Rinehart and Winston, 1986.

Superman: A Pop-Up Book, illustrated by Curt Swan, Bob Oksner and Jerry Serpe. Ib Penick, paper engineer. Random House, 1979.

Those Fabulous Flying Machines: A History of Flight in Three Dimensions with Punch-out Plane Model by Seymour Reit, illustrated by Frank Ossmann, Randy Weidner. Ib Penick, paper engineer. Macmillan Publications, 1985.

David Rosendale, Rodger Smith, Paper Engineers.
Flight: Great Planes of the Century by Donald S. Lopez, illustrated by William S. Phillips. David Rosendale and Rodger Smith, paper engineers. Viking, 1985.

Robert Sabuda, Paper Engineer.

12 Days of Christmas: A Pop-Up Celebration by Robert Sabuda. Little Simon, 1996.

The Christmas Alphabet by Robert Sabuda. Orchard Books, 1994.

A Kwanzaa Celebration: A Pop-Up Book by Nancy Williams. Robert Sabuda, illustrator and paper engineer. Little Simon, 1995.

José R. Seminario, Paper Engineer.

Skeleton Closet: A Spooky Pop-Up Book by Steven Guarnaccia. José R. Seminario, paper engineer. Hyperion Books for Children, 1995.

Rodger Smith, Paper Engineer.

The Voyage of Columbus in His Own Words by Stacie Strong, illustrated by Michael Welply. Designed by Jon Z. Haber. Rodger Smith, paper engineer. Sears, Roebuck and Co., 1991.

The Wheels On The Bus: A Book with Parts that Move adopted and illustrated by Paul O. Zelinsky. Rodger Smith, paper engineer. Dutton's Children's Books, 1990.

Rodger Smith, Helen Balmer, Paper Engineers.

Botticelli's Bed & Breakfast by Jan Pieńkowski. Rodger Smith and Helen Balmer, paper engineers. Simon & Schuster, 1996.

Marcin Stajewski, James Roger Diaz, Paper Engineers.

Gossip by Jan Pieńkowski. Marcin Stajewski and James Roger Diaz, paper engineers. Price Stern Sloan, 1983.

John Strejan, Paper Engineer.

Animal Homes by Alice Jablonsky, illustrated by Jeffrey Terreson. John Strejan, paper engineers. National Geographic Society, 1989.

Explore A Tropical Forest by Peggy Winston, illustrated by Barbara Gibson. John Strejan, paper engineer. National Geographic Society, 1989.

Leonardo da Vinci: The Artist, Inventor, Scientist in Three-Dimensional, Movable Pictures by Alice Provensen and Martin Provensen. John Strejan, paper engineer. Viking, 1984.

John Strejan, David A. Carter, Paper Engineers.

Peter and the Wolf: A Mechanical Book by Sergei Prokofiev, illustrated by Barbara Cooney. John Strejan and David A. Carter, paper engineers. Viking Kestrel, 1985.

John Strejan, James Roger Diaz, David Rosendale, David Pelham, Paper Engineers.
The Facts of Life: Three-Dimensional, Movable Illustrations Show the Development of a Baby From Conception to Birth by Jonathan Miller and David Pelham. John Strejan, James Roger Diaz, David Rosendale and David Pelham, paper engineers. Viking, 1984.

John Strejan, David Rosendale, Paper Engineer.
Sailing Ships by Ron van der Meer and Alan McGowan, illustrated by Borje Svensson. John Strejan and David Rosendale, paper engineers. Viking, 1984.

Ron van der Meer, Paper Engineer.
Fungus the Bogeyman: Plop-Up Book by Raymond Briggs. Ron van der Meer, paper engineer. Hamish Hamilton Children's Books, 1982.

Hugh Johnson's Pop-Up Wine Book by Hugh Johnson. Ron van der Meer, paper engineer. Harper and Row, 1989.

The Snowman: A Pop-Up Book with Music by Raymond Briggs and Ron van der Meer. Ron van der Meer, paper engineer. Hamilton Children's, 1986.

Tiny Kittens illustrated by Lesley Ann Ivory. Ron van der Meer, paper engineer. Abbeville Press, 1990.

Ron van der Meer, Mark Hiner, Paper Engineers.
The Working Camera: The World's First Three-Dimensional Guide to Photography Made Easy by John Hedgecoe and Ron van der Meer. Ron van der Meer and Mark Hiner, paper engineers. Harmony Books, 1986.

Van der Meer Paper Design, Paper Engineering.
The Great Movies Live!: A Pop-Up Book by Maxim Jakubowski and Ron van der Meer. Design by Van der Meer Paper Design. Simon & Schuster, 1987.

The Art Pack: A Unique Three-Dimensional Tour Through the Creation of Art over the Centuries – What Artists Do, How They Do It, and the Masterpieces They Have Given Us by Christopher Frayling and Helen Frayling. Paper engineering by Van der Meer Paper Design. Knopf, 1992.

The Music Pack: A Unique, Three-Dimensional Tour Through the Creation of Music Over the Centuries: What Musicians Do, How They Do It, and the Masterpieces They Have Given Us by Ron van der Meer and Michael Berkeley, illustrated by Paul Crompton. Paper engineering by Van der Meer Paper Design. Alfred A. Knopf, 1994.

Van der Meer Paper Design, Paper Engineering.
The Phantom of the Opera: The Sensational Musical in Three Dimensions. Pop-up scenes based on the original stage designs by Maria Björnson, illustrated by Paul Crompton. Paper engineering by Van der Meer Paper Design. Harper & Row, 1988.

Ron van der Meer Paper Design, Paper Engineering.
Inside the Personal Computer: An Illustrated Introduction In 3 Dimensions: A Pop-up Guide by Sharon Gallagher, illustrated by Wayne McLoughlin, Christopher Finch and Johnathan Wright. Paper Engineering by Ron van der Meer Paper Design. Abbeville Press, 1984.

Paul Wilgress, Paper Engineer.
The Ultimate Pop-Up Cocktail Book by Graham Brown and Michael Wells, illustrated by Geoffrey Appleton. Paul Wilgress, paper engineer. Ward Lock, 1984.

The Weather Pop-Up Book by Francis Wilson, illustrated by Philip Jacobs. Paul Wilgress, paper engineer. Little Simon, 1987.

Titles nominated with uncredited paper engineers.
Don't Go Out Tonight: A Creepy Concertina Pop-Up by Babette Cole. Doubleday, 1982.

The Nativity: A Glorious Pop-Up Book. Text by Veronica Heley. Illustrated by Francesca Crespi. Rooster Books, 1994.

Peekaboo! A First Pop-Up Book by Mathew Price, illustrated by Jean Claverie. Alfred A. Knopf, 1985.

The Pop-Up White House: Open the Book and You're Ready to Play President and First Lady! Complete with Ready-to-Assemble Furniture and Your Own Personal MX Missile by John Boswell and Ron Barrett, illustrated by Gary Hallgren and Ron Barrett. Bantam Books, 1983.

Ruckus Rodeo by Red Grooms. Essay by Barbara Haskell. Harry N. Abrams, Inc., 1988.

Tim Burton's Nightmare Before Christmas: A Super Pop-Up by Tim Burton. Mouse Works, 1993.

The Movable Book Society
Outstanding Emerging
Paper Engineer Prize
2014 – 2018

The Movable Book Society
Outstanding Emerging Paper Engineer Prize History

The Movable Book Society Outstanding Emerging Paper Engineer Prize originated in 2014. MBS Board members Larry Seidman, a noted book collector, and book artist Shawn Sheehy, initiated the idea of a prize as an encouragement for young people involved with movable and pop-up book creation and production.

This biennial honor recognizes excellence in paper engineering among undergraduate and graduate students worldwide. Entrants must be registered students or have just completed a course of study by the spring of the MBS conference year. Qualifying projects must include pop-up and/or movable structures made with paper and created during a course of college study.

"The Movable Book Society offers the only award of its kind for students," says Emily Martin, of the University of Iowa Center for the Book. "It is important because it shows students that there is an interest in the use of paper engineering after receiving their degree."

Applications for the prize are available by spring of the conference year on the MBS website. The entire MBS Board evaluates the submissions and selects the winner and honorable mentions. At the 2016 conference in Boston, the Ticknor Society president Marie Oedel participated in the judging.

Each prize winner receives an opportunity to present at the MBS Conference, waved conference fees, a stipend to assist with travel costs, and one year's MBS membership.

To date, students representing schools in four different countries have entered!

1. Cambridge School of Art, Cambridge, England
2. College for Creative Studies, Detroit, MI
3. Corcoran School of the Art and Design, Washington, D.C.
4. De La Salle–College of Saint Benilde, Manila, Philippines
5. Fashion Institute of Technology, New York, NY
6. Florida Atlantic University, Boca Raton, FL
7. Institute of Technology Bandung, Indonesia
8. Marywood University, Scranton, PA
9. Pratt Institute, Brooklyn, NY
10. Tisch School of the Arts, New York, NY
11. University of Alabama, Tuscaloosa, AL
12. University of Iowa Center for the Book, Iowa City, IA
13. University of Southern Maine, Portland, ME
14. University of the West of England, Bristol
15. Washington University, St. Louis, MO

Vanessa Yusuf
Institute of Technology Bandung, Indonesia

Bhinneka Tunggal Ika:
A Pop-up Book of 10 Indonesian
Public Holidays (2018)

Vanessa Yusuf is a paper engineer, lecturer, and designer, born in 1994 in Bandung, Indonesia. She completed her Master's degree in Design at The Institute of Technology Bandung in 2018. Currently she is teaching Visual Communication Design at Petra Christian University, Surabaya, Indonesia. She aspires to spread the excitement of paper engineering through her artwork, workshops, and college class instruction.

"Bhinneka Tunggal Ika," or "Unity in Diversity," is the motto of The Republic of Indonesia. This multi-tiered, 360° pop-up book uses a range of paper mechanisms, such as pop-ups and pull-tabs, to celebrate ten Indonesian public holidays. The holidays include New Year, Chinese New Year, Silent Day, Easter Day, Eid al-Fitr, Vesak Day, Pancasila Day, Eid al-Adha, Indonesia Independence Day, and Christmas. This unique book also highlights six different religions: Islam, Protestant Christianity, Catholicism, Hinduism, Buddhism, and Confucianism. Overall, *Bhinneka Tunggal Ika* aims to grow a sense of unity, respect, and tolerance among people.

2018 OUTSTANDING EMERGING PAPER ENGINEER
HONORABLE MENTION

Sandy Horsley
Cambridge School of Art, Cambridge, England

PAUSE (2017)

Sandy Horsley is a writer, illustrator and printmaker based in Suffolk, England. After a career in magazine publishing, Horsley attended the Cambridge School of Art, where she graduated with distinction with a Master's degree in Children's Book Illustration. She combines pop-up techniques with traditional printmaking in her work. Her debut picture book is titled *Selfie*.

"With my book *PAUSE*, I wanted to use pop-ups and traditional printmaking to explore feelings of digital information overload," shared Horsley. "I wanted to create a book that encourages us to find balance and take some time away from technology. To regain some control, press the pause button, take some slow breaths and marvel at the precious, natural world around us."

2018 Outstanding Emerging Paper Engineer
Honorable Mention

Amy Nayve
College of Saint Benilde, Manila, Philippines

Amy Nayve is a self-taught paper engineer whose creations are marked by playful creativity and childlike wonder. She was internationally recognized for "Popfolio", and her work has been featured on national television, newspapers and online media in the Philippines. Amy founded Pumapapel Pop-Up Design Studio in 2018 and now spreads the joy of paper engineering through her art and workshops.

Photo by Ecko Dizon

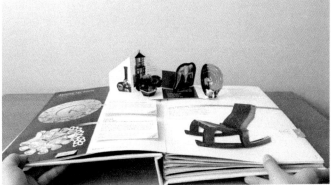

Popfolio (2017)

Popfolio is an interactive pop-up book featuring the best of Amy's Industrial Design college projects. Pop-up and movable elements mimic actual objects including a clock that moves and a chair that rocks. An innovative feature is the "Amylon Volvelle," a mechanism Amy created that makes a pop-up rise as it revolves on the spread.

Nicholas Danish
College for Creative Studies, Detroit, Michigan

Nicholas Danish is an illustrator and paper engineer based in Michigan, with a degree in Illustration from the College for Creative Studies. His recent pop-up books and card designs have centered on the city of Detroit, silent films, and movie monsters via portraiture. He strives to create unique works of art that are both nostalgic and timeless.

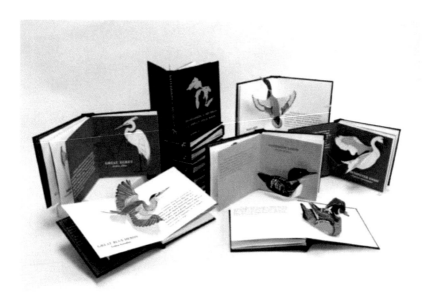

Photo by Nick Danish and Esther Licata

Waterbirds of Michigan: A Pop-Up Field Book (2015) by Esther Licata and Nicholas Danish is a serigraph printed book depicting six different waterbird species commonly found in Michigan. Each spread features a different bird in its own unique pop-up designed by Nicholas and beautifully illustrated by Esther. He and Esther worked together on writing, screen-printing, and hand assembling a limited edition of 30 books.

Nicholas Danish
College for Creative Studies, Detroit, MI

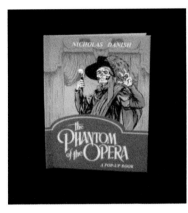 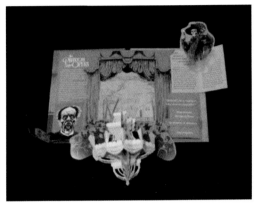

The Phantom of the Opera: A Pop-Up Book (2015)
This single page pop-up book focuses on the 1925 classic silent film. When one first opens the book, they are greeted with the fall of the chandelier, as it seems to drop into their very lap. Side flaps also depict the Phantom's unmasking, the Masque of the Red Death, and a mini tunnel book showing the passageways beneath the opera house.

Danny Evarts
University of Southern Maine, Portland, ME

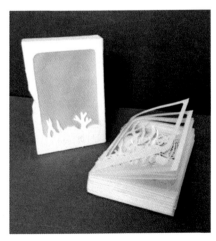 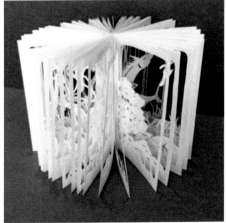

Ghost Reef (2015), is a hand cut artist's book with stitched tape binding.
Open: 13" round x 9" tall.

Kimberly Maher
University of Iowa, Iowa City, IA

Kimberly Maher is a book artist and educator living in Iowa City. She earned her MFA in Book Arts with distinction from the University of Iowa Center for the Book where she studied letterpress printing, hand papermaking, and bookbinding. She is a printer and illustrator with a particular fondness for pop-up and movable book structures. Her work has been exhibited and collected throughout the U.S.

Two Lives, a letterpress printed artist book, features movable hand-cut pochoir illustrations and reveals underlying themes of family and purpose. The moving parts serve as visual metaphors for social interactions. The book was inspired by Daniel Wallace's novel, *The Kings and Queens of Roam*.

Two Lives (2014, Edition size 30)

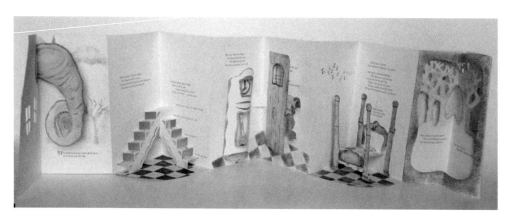

Crooked (2011, Edition size 20)

Crooked. Carousel pop-up book, featuring hand-cut pochoir illustrations and letterpress printing from hand-set De Roos type. *Crooked* features nursery rhyme verses and lyrics in which the absurdity of the narrative is amusing and farcical.

2014 OUTSTANDING EMERGING PAPER ENGINEER
HONORABLE MENTIONS

Andrew Binder
Florida Atlantic University, Boca Raton, Florida

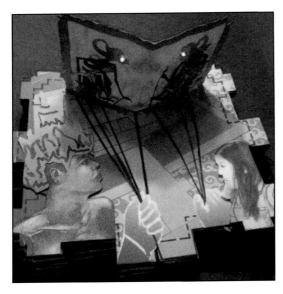

Migratory Deviations is a part of Binder's UNESCO world heritage artists' book series and includes collage objects, string, LED lights, a spoken Colophon and photographs by Binder of monuments in Thailand, Cambodia, India, Sri Lanka, Nepal, Vietnam, Singapore, and Indonesia.

Several artists' books by Andrew Binder (February 22, 1967- July 22, 2018) are in the Jaffe Center for Book Arts collection at FAU.

Migratory Deviations (2014)

Gabriela Romagna
University of the West of England, Bristol

Random House is a pop-up home made with a variety of "random" materials. The piece folds flat into a book.

Open: 39 cm height x 20.5 cm width x 50 cm length.

Random House (2014)

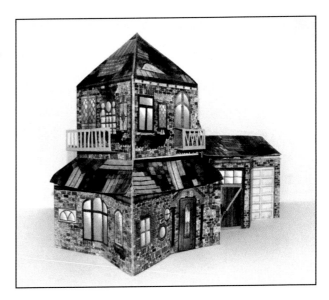

The Meggendorfer Prize
for Best Artist Book
2014 – 2018

The Meggendorfer Prize for Best Artist Book History

The Movable Book Society announced the first Meggendorfer Prize for Best Pop-Up or Movable Artist Book, as it was initially called, in 2014. The goal was to recognize outstanding three-dimensional books not commercially published or mass produced. The nominated books invoke the spirit of originality and innovation that Lothar Meggendorfer instilled in his now classic movable and pop-up creations.

To participate, book artists or paper engineers must be at least 21 years of age. Qualifying books must include pop-up and/or movable structures and have been created in the three years proceeding submission to the competition.

The MBS Board evaluates all submissions and narrows the field to ten books. A jury of two invited judges chooses the winner and honorable mentions by viewing the physical books at the biennial MBS conference. Each year's winner receives a trophy. Past invited judges have included:

2018 MBS Conference in Kansas City, MO
Chuck Fischer, an American muralist, product designer and author of various bestsellers, including *The White House Pop-up Book.*

Kevin Steele, a graphic designer and paper engineer based in Atlanta, Georgia. His artist's books are in the library collections of the Metropolitan Museum of Art, UCLA and University of Washington.

2016 MBS Conference in Boston, MA
Monika Brandrup, the Vice President and Creative Director at Up With Paper.

Dorothy A. Yule, a book artist and proprietor of Left Coast Press. Her unique and limited-edition books are in various collections, including Mills College and the National Art Library of the Victoria and Albert Museum.

2014 MBS Conference in Philadelphia, PA
Emily Martin, the proprietor of Naughty Dog Press. She has taught bookbinding and book arts at the University of Iowa Center for the Book since 1998.

Kyle Olmon, an Assistant Librarian at the auction house Christie's. He studied paper engineering under famed practitioners Andrew Baron, Robert Sabuda and Matthew Reinhart before creating the trade pop-up book *Castle: Medieval Days and Knights.*

Colette Fu
桃花源記 *Tao Hua Yuan Ji: Source of the Peach Blossoms* (2018)

Colette Fu received her MFA in Fine Art Photography from the Rochester Institute of Technology in 2003, and soon after began devising complex compositions that incorporate photography and pop-up paper engineering. Her pop-up books are included in the National Museum of Women in the Arts, Library of Congress, Metropolitan Museum of Art and many private and rare archive collections.

桃花源記 Tao Hua Yuan Ji: Source of the Peach Blossoms (2018)

Jin Dynasty poet, Tao Yuanming, wrote of a traveler who came upon an isolated peach blossom valley beyond a cave where people seeking political refuge lived an ideal, harmonic life with nature and each other. Although villagers told the traveler not to tell of their location, he vainly marked his path and sent government officials who were unable to find it. You can glimpse the secret location in Colette Fu's *Tao Hua Yuan Ji: Source of the Peach Blossoms.*

Graham Patten
Call Me Trimtab (2014)

Graham Patten is a book conservator at the Boston Athenaeum. He previously worked in conservation at the Northeast Document Conservation Center, Northwestern University Library, and Harvard University Weissman Preservation Center. In his artistic pursuits, Patten often focuses on dynamic sculptural and mechanical elements, and merging these features with innovative book structures.

Call Me Trimtab (2014). Open: 10.91 x 15 x 7.4 inches

Call Me Trimtab is a tribute to architect, inventor, and futurist R. Buckminster Fuller. The book is an allusion to Fuller's "tensional integrity" structures, such as his famous geodesic sphere known as the "Bucky Ball". When the book is fully opened the bamboo spars and linen cords unfurl the letterpress pages in a balance between tension and compression. The woodblock portrait is carved and printed by the binder.

Bryan Kring
Lunae Secutor (2015)
1st Runner Up Honors

Bryan Kring is an artist who combines his love of drawing, painting, printing, tinkering, storytelling and daydreaming in Oakland, California.

Lunae Secutor (2015). Open: 5 x 2.75 x 2.25 inches.

Tucked into the cover of this insect specimen is a description of the *Lunae Secutor* (Moon Chaser), a caterpillar which is unable to metamorphose into a butterfly. At midlife, upon the realization of this limitation, the caterpillar becomes depressed and its natural attraction to the moon grows stronger. When the crank is turned the moon illuminates and the caterpillar "walks" toward it.

Damien Prud'homme
Entomologie Origamique (2015)
2nd Runner Up Honors

Damien Prud'homme graduated from Cambrai Art School – graphic design and communications course. He also studied pop-up techniques at the Maryse Eloy School of Arts (Paris) in a program taught by famed pop-up artist Philippe UG.

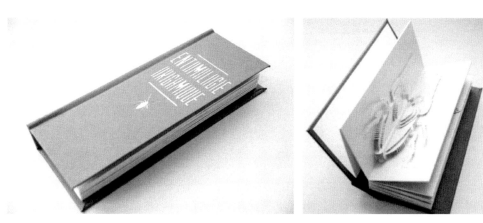

Entomologie Origamique (2015). Edition size: 10

"I like that you can link my work to illustrated plates from XVIIIth centurie zoological atlases," writes Prud'homme. "Masahiro Chatani's work, who developed what he called "origamic architecture," greatly influenced my work. In my creations, giving volume to animal exoskeletons, you will find this idea that this animal body becomes an architectural structure."

Dorothy A. Yule
Memories of Science (2012)

Dorothy A. Yule studied printmaking at St. Martins School of Art and has a Masters in Book Arts from Mills College. Most of her books are written in rhyming verse and incorporate pop-up and movable structures. She often collaborates with her twin sister, Susan Hunt Yule, on books produced under her imprint, Left Coast Press. She and her twin also make eccentric movable ephemera as Les2Twins.

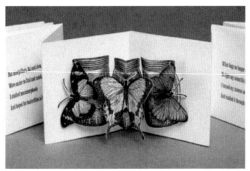 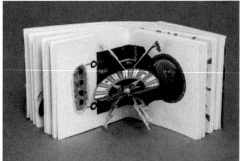

Memories of Science, 2012, Photo by Luz Marina Ruiz

"Science fascinated me when I was young," shared Yule. "I lost the academic thread somewhere between physics and calculus, but I sublimated my scientific desires into the making of artist's books. *Memories of Science* recalls in verse my experiences as a young scientist: the early lure of bugs, the shining world of astronomy, experiments in magnetism and the electric motor, and biology with its seductive taxonomy."

The Movable Book Society
Lifetime Achievement Award

Movable Book Society Lifetime Achievement Award

At the 2000 MBS Conference in New York City, the Society announced that, for the first time, it would present a lifetime achievement award to recognize an individual who has made significant career contributions to the field of interactive and movable books.

Marsha Apgood presents the MBS Lifetime Achievement Award
to Waldo Henley Hunt at Intervisual Books.
Source: *Movable Stationery, vol. 8, no. 4, Nov. 2000, p. 18.*

Waldo Hanley Hunt was born on November 28, 1920, in Chicago, Illinois. He worked in California at Eitel N McCullough, a radio tube factory, before enlisting in the U.S. Army in 1944. He fought in the Battle of the Bulge. After the war, he worked several years in advertising in Los Angeles.

It was a chance encounter with a pop-up book by Vojtěch Kubašta that fascinated Waldo Hunt and would eventually usher in the Second Golden Age of Pop-Up Books, a rise in publishing that followed the scarcities of World War I, when production and printing resources were limited.

Hunt founded Graphics International to publish pop-up advertising and books. After seeing that children's pop-up book by Kubašta in a toy store window, Hunt later recalled, "I knew I'd found the magic key…. No one was doing pop-ups in this country (the United States). No one could afford to make them here. They had to be done by hand, and labor was too expensive. I knew printers and engineers…" This inspiration led to a series of 14 different magazine ad campaigns for Wrigley's gum featuring zoo scenes. One million magazine inserts were manufactured for each zoo scene—an unheard-of production at the time. Hunt also created the first pop-up books for Random House in the mid-1960s. This partnership would produce more

than 30 collectible pop-up titles, including *Bennett Cerf's Pop-Up Riddle Book* (1966). Graphics International was sold to Hallmark Cards, Inc. in 1974.

In 1975, Hunt formed Intervisual Communications (later Intervisual Books), which would produce some of the most sought-after pop-up books from the mid-20th century, including *Haunted* House (1979), *The Human Body* (1983), *Disney's The Lion King: Pop-Up Book* (1994), *Richard Scarry's Biggest Pop-Up Book Ever!* (1998), and *Harry Potter and the Chamber of Secrets* (2002).

Renowned paper engineers worked with the company such as Ib Penick, former VP and Creative Director and David A. Carter. According to a 1987 *Los Angeles Times* article, the company produced about 70% of the novelty children's books in the market and employed most of the paper engineers working in the United States.

The U.S. Patent Office issued Hunt several patents, including ones for a bendable figurine book (no. 5,833,509), a children's book with hologram features (no. 5,788,286), and a toy train and book assembly (no. 5,961,149).

Hunt amassed 4,000 antique and contemporary pop-up and movable books. About 300 titles were featured in the 2002 Los Angeles Central Library exhibit "Pop Up! 500 Years of Movable Books." He also donated about 500 antique pop-up books to the University of California, Los Angeles.

Waldo Hunt was awarded the Movable Book Society Lifetime Achievement Award in 2002. Unable to attend the MBS Conference in New York, publishing colleague Jerry Harrison accepted the award in Hunt's place. Later, MBS member Marsha Apgood presented the award to Hunt, in the form of beautifully etched glass bookends.

Longtime MBS member and "king of pop-ups" Waldo Hunt died in 2009, at the age of 88. He was survived by his wife Patricia; and daughters Kimberly, Jamie and Marsha.

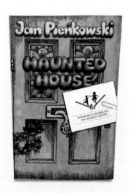 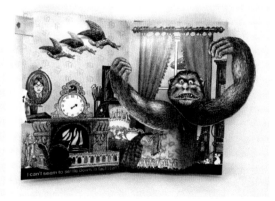

Intervisual Books, Inc. Annual Report. Santa Monica, CA, 1992. The twenty-four page financial report included the *Haunted House* pop-up book. More than 1 million copies of *Haunted House* were sold in 13 languages, in nearly 30 countries by 1992.

Movable Book Society Board of Advisors

The Board of Advisors is responsible for the integrity and development of the Society and serves for either two- or four-year terms. Advisors have a common love for movable and pop-up books and have included book collectors, book dealers, paper engineers, graphic designers, book artists, publishers and librarians.

Over the years, Advisors have volunteered time, talent and resources to preserving and promoting the organization and elevating movable and pop-up books and their makers.

The Movable Book Society Board of Advisors Past and Present
September 2018, Kansas City, Missouri

Clockwise from the top: Kyle Olmon, Denise D. Price, Shawn Sheehy (Board Director), Larry Seidman, Monika Brandrup, Frank Gagliardi (former advisor), Kyra E. Hicks, Ellen G. K. Rubin, Ann Montanaro Staples (MBS Founder and former advisor), Isabel Uria, and Jason Brehm.

Past Board of Advisor members not pictured include Abigail Ranson Mangan, Adie Peña and Robert Sabuda.

Paper Engineer, Book Artist and Collector Index

Allen, Keith, *7*
Anderson, Kelli, *7, 73*
Apgood, Marsha, *68, 69*
Arizpe, Simon, *6, 7, 73*
Arnold, Shelby, *73*
Augarde, Steve, *33*

Balmer, Helen, *42, 48*
Bantock, Nick, *42*
Baron, Andrew, *20, 27, 28, 37, 61*
Barton, Carol, *ii*
Bataille, Marion, *12, 19, 20*
Bateson, Maggie, *42*
Belsey, Katherine, *73*
Bennett, Andrew, *33*
Biederstädt, Maike, *7, 73*
Biggs, Jonathan, *42*
Binder, Andrew, *59*
Birmingham, Duncan, *ii*
Blakemore, Sally, *20, 37*
Boatright, Diane, *42*
Boisrobert, Anouck, *9, 12, 15, 17*
Brandrup, Monika, *61, 70*
Brehm, Jason, *4, 70*
Broekhuis, Eric, *73*
Brown, Alan, *12*
Brown, Graham, *24*
Bruandet, Jérôme, *42*

Carter, David A., *ii, 12, 20, 23, 25, 26, 28,*
 31, 32, 33, 35, 37, 42, 43, 48, 69
Charbonnel, Olivier, *39*
Charvet, Julie, *73*

Dahmen, Peter, *73*
Danish, Nicholas, *56, 57*
Deesing, Jim, *31*
Denchfield, Nick, *33*
Diaz, James Roger, *ii, 23, 25, 28, 31, 37,*
 43, 44, 48, 49
Dijs, Carla, *32, 33, 46*
Dudley, Dick, *31*
Duppa-Whyte, Vic, *44*

Evarts, Danny, *57*

Ferguson, Richard, *13, 33*

Ferrari, Angelo, *73*
Finch, Keith, *28, 29, 32, 33*
Fischer, Chuck, *61*
Fletcher, Corina, *20, 23, 37, 38, 45*
Foster, Bruce, *9, 12, 17, 20, 23, 26, 28, 32,*
 33, 44, 73, 77
Froehlich, Julia, *12*
Fry, Patricia, *21*
Fu, Colette, *62*

Gagliardi, Frank, 70
Guzmán, Eugenia, *37*

Hamilton, Allen, *34*
Hansen, Biruta Akerbergs, *32, 33*
Hawcock Books, *34*
Hawcock, David, *10, 13, 21, 26, 28, 34, 38,*
 45
Hawke, Richard, *38*
Hawkey, Raymond, *45*
Hicks, Kyra E., *1, 70*
Hiner, Mark, *38, 40, 45, 49*
Hirata, Sheila, *73*
Honeybone, Ian, *45*
Horsley, Sandy, *54*
Hunt, Waldo, *25, 31, 35, 41, 68, 69*
Hutchins, Ed, *41*

Ignestam, Lena, *73*
Ita, Sam, *17, 18, 21, 23*

Jablow, Renee, *20*
Janssen, Charlotta, *34*
Johnston, Damian, *38*
Johnstone, Mat, *33, 34*

Kelly, Rob, *73*
Kim, Yoojin, *7, 73*
Kondeatis, Christos, *45*
Kring, Bryan, *64*
Kubašta, Vojtěch, *45, 68*
Kwan, Wai-Yin, *73*
Kyle, Hedi, *ii*

Lambert, Jonathan, *34*
Le Vilain, Aurore, *73*
Licata, Esther, *56*
Littlejohn, Claire, *45*

Lo Monaco, Gérard, *9*, *21*
Lokvig, Tor, *32*, *33*, *43*, *45*, *46*

Magaud, Camille, *73*
Maher, Kimberly, *58*
Marshall, Ray, *9*, *13*, *14*, *17*, *21*, *46*
Martin, Emily, *52*, *61*
McCarthy, Courtney Watson, *7*, *9*, *12*, *17*, *73*
McTeigue, Jane, *38*
Meggendorfer, Lothar, *1*, *3*, *61*
Meyer, Dennis K., *28*, *42*, *46*
Meyer, Rosston, *7*
Missiroli, Massimo, *28*
Moerbeek, Kees, *17*, *23*, *26*, *28*, *29*, *31*, *32*, *33*, *34*, *38*, *46*
Montanaro, Ann. *See:* Staples, Ann Montanaro
Moret, Frederic, *38*
Moscovich, Ivan, *38*
Moseley, Keith, *31*, *39*, *46*, *47*
Murphy, Chuck, *23*, *32*, *33*, *39*, *41*, *47*

Nayve, Amy, *55*

Oedel, Marie, *52*
Olmon, Kyle, *24*, *61*, *70*, *73*

Patten, Graham, *63*
Pease, Pamela, *29*
Pelham, David, *7*, *24*, *25*, *34*, *42*, *43*, *47*, *49*
Peña, Adie, *3*, *41*, *70*
Penick, Ib, *47*, *69*
Pieńkowski, Jan, *25*
Price, Denise D., *9*, *10*, *70*
Prud'homme, Damien, *65*, *73*

Radevsky, Anton, *34*
Ramsay, Stephen, *34*
Ranson Mangan, Abigail, *70*
Reinhart, Matthew, *9*, *11*, *12*, *17*, *18*, *21*, *22*, *24*, *26*, *29*, *39*, *61*
Rigaud, Louis, *9*, *12*, *15*, *17*
Rives, *35*, *39*
Romagna, Gabriela, *59*
Ron van der Meer Paper Design, 50
Rootenberg, Howard, *41*
Rosendale, David, *44*, *47*, *49*

Rubin, Ellen G. K., *ii*, *3*, *4*, *32*, *41*, *70*

Sabuda, Robert, *3*, *9*, *12*, *17*, *18*, *21*, *24*, *26*, *30*, *32*, *33*, *35*, *36*, *39*, *41*, *48*, *61*, *70*
Santoro Graphics, Inc., *18*, *21*, *24*
Seidman, Larry, *52*, *70*, *73*
Seminario, José R., *46*, *48*
Sendak, Maurice, *32*
Seymour, Peter, *31*
Sheehy, Shawn, *ii*, *8*, *10*, *52*, *70*, *73*
Simmons, Heather, *39*
Smith, Keri, *35*
Smith, Rodger, *21*, *35*, *39*, *40*, *44*, *47*, *48*
Smyth, Iain, *24*, *32*, *33*, *35*, *40*
Stajewski, Marcin, *43*, *44*, *48*
Staples, Ann Montanaro, *ii*, *1*, *3*, *32*, *41*, *70*, *73*
Steele, Kevin, *61*
Stickland, Paul, *29*
Strejan, John, *25*, *31*, *43*, *44*, *46*, *47*, *48*, *49*

Takeda, Hiromi, *73*
Tavernier, Sarah, *10*
Teague-Cooper, Vicki, *40*
The Popuplady. *See: Rubin, Ellen G. K.*
Tice-Gilbert, Jess, *73*
Traganza, Betty, *41*

UG, Philippe, *13*, *65*
Uria, Isabel, *70*, *73*

Van der Meer Paper Design, *49*, *50*
van der Meer, Ron, *24*, *40*, *49*
von Stemm, Antje, *40*
Vosough, Gene, *13*, *20*

Wilgress, Paul, *50*
Wilson-Max, Ken, *29*, *32*, *33*, *40*

Yeretskaya, Yevgeniya, *10*, *13*, *16*, *18*, *73*
Yeung, Tina, *73*
Young, Jay, *40*
Yule, Dorothy A., *61*, *66*, *73*
Yusuf, Vanessa, *53*

Zerkin, Becca, *10*

A to Z: Marvels in Paper Engineering
Limited-edition, pop-up alphabet collection!
ISBN: 978-0-692-09894-3 $75.00 USD

A to Z: Marvels in Paper Engineering celebrates the 25th anniversary of The Movable Book Society. This limited-edition collection—only 2,000 copies—of 26 individual pop-up cards was designed by some of the most talented paper engineers in the world. Each full-color pop-up card includes a three-dimensional interpretation of a letter in the alphabet, the artist's image and their story of inspiration. The collection is housed in a clamshell box designed by Isabel Uria, includes a bonus pop-up card engineered by Bruce Foster, and features a brief history of MBS by Ann Montanaro Staples, along with an introductory essay by collector-of-note Larry Seidman.

Featured Designers in the A to Z collection:

A - Simon Arizpe

B - Camille Magaud

C - Peter Dahmen

D - Dorothy A. Yule

E - Eric Broekhuis

F - Yoojin Kim

G - Jess Tice-Gilbert

H - Angelo Ferrari

I - Lena Ignestam

J - Hiromi Takeda

K - Rob Kelly

L - Courtney Watson McCarthy

M - Wai-Yin Kwan

N - Kelli Anderson

O - Kyle Olmon

P - Maike Biederstädt

Q - Aurore Le Vilain

R - Julie Charvet

S - Isabel Uria

T - Sheila Hirata

U - Shelby Arnold

V - Damien Prud'homme

W - Shawn Sheehy

X - Katherine Belsey

Y - Tina Yeung

Z - Yevgeniya Yeretskaya

Best Pop-Up Books

Discover a new world of 3D books

- YouTube video reviews
- Exclusive interviews
- Pop-up book photo galleries

- Templates and tutorials
- News and upcoming titles
- Pop-up book gift guides

Watch our video reviews, discover new books, find the most beautiful pop-up books for kids and adults, galleries, news and much more!

Welcome to BestPopUpBooks.com!

Join the Movable Book Society today!

The Society is open to anyone interested in pop-up and movable books. This includes pop-up book collectors and dealers, artists' book creators, paper engineers, librarians, gallery owners and curators, editors and publishers. Institutional members are also welcome. Dues cover one year of benefits.

5 REASONS TO JOIN!

1. **Connect with pop-up and movable book enthusiasts like you.**
 The Society membership list is available on request.

2. **Read and share the latest news on books, paper engineers, and collections.**
 The *Movable Stationery* newsletter is edited by noted paper engineer Bruce Foster. You are welcome to submit articles or news of your own.

3. **Attend the biennial conference.** Members receive a discounted conference rate.

4. **Vote for the next Meggendorfer Prize for Best Paper Engineering winner.**

5. **Support your "community".** Your membership dues help cover admin costs.

Name: Email:

_____ _____

Address:

❑ **Book** ❑ **Paper** ❑ **Book** ❑ **Book** ❑ **Other**
 Collector **Engineer** **Artist** **Dealer**

❑ $30.00 Check / $32.00 PayPal for members ❑ $35.00 Check / $37.00 PayPal for members
 in the United States outside of the United States

Send To: The Movable Books Society, c/o Shawn Sheehy, P.O. Box 477689, Chicago, IL 60647 USA.
Or, if you prefer to pay with PayPal, visit: movablebooksociety.org/membership

Made in the USA
San Bernardino, CA
07 January 2020